Victorian
Book Illustration

MORNA DANIELS

The British Library

© 1988 The British Library
Board

Published by
The British Library,
Great Russell Street,
London WC1 3DG

and 27 South Main Street,
Wolfeboro, New Hampshire
03894–2069

British Library Cataloguing in
Publication Data

Daniels, Morna
 Victorian book illustration.
 1. British illustrations.
 Illustrations for books,
 1837–1901
 I. Title II. British Library
 741.64′0941

 ISBN 0–7123–0157–7

Designed by Roger Davies
Typeset in Monophoto Ehrhardt
by August Filmsetting, Haydock,
St Helens
Origination by York House
Graphics, Hanwell
Printed in England by Jolly and
Barber Ltd., Rugby

NOTES
1. Capitalisation in book titles
follows modern bibliographic
practices.
2. Children's books have not
been included here as they are
dealt with in another book in the
same British Library series,
Illustrated children's books by John
Barr (1986).
3. All titles quoted in this work
are published in London unless
otherwise stated.

Front cover: see **26** *and* **73**.

Back cover: see **64**.

Title-page: 'The tournament'
from *In Fairyland* (Longman,
1870), illustrated by
Richard Doyle.
[1876.e.18]

Title verso: see **58**.

Inside front cover: **John
Tenniel**. Lewis Carroll's
*Alice's Adventures in
Wonderland*
(1866 [1865]).
[C.59.g.11]

*Inside back cover: A book of
images*, drawn by
W.T. Horton and introduced
by W.B. Yeats (Unicorn Press,
1898). 'The path to the moon'.
Yeats suggests this is the
'crooked way' of the Bible.
[LR.269.a2/2]

*Contents page: Pen and pencil
pictures from the poets* by
W.P. Nimmo (Edinburgh,
1866).
Illustration by Keeley
Halswelle, 'The Wreck of the
Hesperus'.
[11651.f.7]

Contents

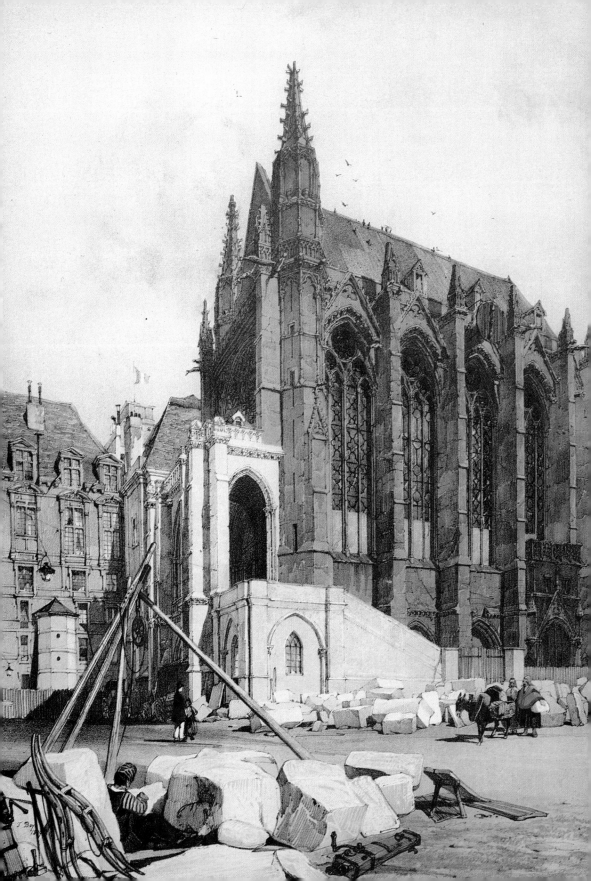

Introduction

The Victorian age saw an immense growth in the reading public. Not only did the population of England and Wales grow from 14 to 33 million, but more people became literate. Working men's colleges, the public library movement, the opening of museums and the popularity of the Great Exhibition of 1851 all bear witness to a popular interest in culture and an earnest desire for self-improvement.

From Easter Monday, 1837, the British Museum opened on public holidays allowing working people to view the collections. The number of readers admitted to the Museum's Department of Printed Books (now the Humanities and Social Sciences division of the British Library) rose from about 230 readers a day in the 1830s to about 500 a day in 1884. Progressively larger reading rooms were replaced by the present circular Reading Room in 1857. Opening hours were limited by the hours of daylight until the introduction of electricity in 1880 when evening opening was possible. Readers included Macaulay, Dickens, Thackeray, Browning, Darwin, Dante Gabriel Rossetti, and Karl Marx. The illustrators Walter Crane and Henry Noel Humphreys drew inspiration from the early printed books and manuscripts they were able to study in the Museum. Complaints that imbeciles were 'parked' in the Reading Room to be out of the way shows the liberal use of the room and explains the heavy wear and tear exhibited by some of the collection's Victorian books, which now require conservation.

Under the 1814 and 1842 Copyright Acts, publishers were required to deposit in the Museum a copy of every book published, but it was not until the 1850s that Antonio Panizzi, the energetic Keeper of the Department of Printed Books, enforced the law.

Cheap wood-pulp paper and increasing mechanisation helped the publishing industry respond to the increased demand for books, and the size of editions increased greatly. Part-publication of books, each part having one or more line illustrations, brought them within the reach of poorer people. Many illustrated magazines also appeared, from Charles Knight's educational *Penny Magazine*, founded in 1832, to literary periodicals like the *Cornhill Magazine* of the 1860s and improving periodicals like *Once a week* and *Good words*. The middle classes also increased in numbers and provided a market for more expensive books.

The 19th century saw a complete revolution from manual to mechanical processes of illustration. The following are the main processes used, though methods were frequently mixed and the final product improved by hand-colouring.

Etched processes
A metal plate is coated with a ground of blackened wax-resist and the design scratched through. The plate is dipped in acid repeatedly to bite out the design, the lines being stopped out with new coats of wax when sufficiently deep. The artist can draw directly on the plate.

Aquatint
This is etching by tones. The plate is speckled with resin and dipped in acid. The acid bites between the specks giving a grainy effect when printed. Stopping out with varnish and repeated dipping gives variations in

1 **Thomas Shotter Boys** (1803–74). *Picturesque architecture in Paris, Ghent, Antwerp, Rouen etc.* Printed by Hullmandel [1839].
[650.b.6]
La Sainte Chapelle, Paris. Boys's style of water-colour, which he translates to the lithographic plate so successfully, must have been influenced by Richard Parkes Bonington, his brilliant but short-lived friend with whom he worked in Paris.

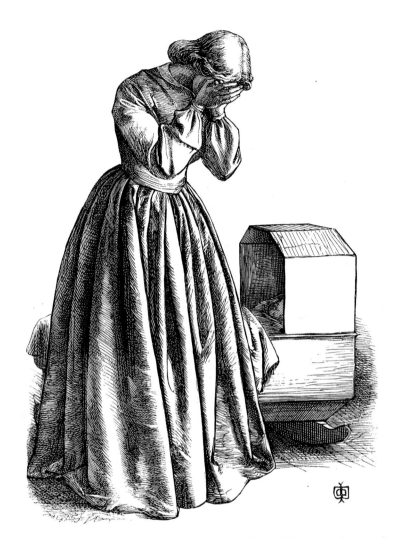

2 J.D. Watson. *English sacred poetry*, edited by R.A. Willmott (Routledge, 1862). [1347.f.13]
'A mother's grief'. Watson (1832–92) came from Scotland and studied at the Royal Academy. His work shows the influence of the Pre-Raphaelites. His specialisation in figure painting is evident in this eloquent design. Wood engraving.

tone, and lines can be etched at the same time. George Baxter, a pioneer of colour printing, used aquatinting to produce a design in tones which he coloured with wood-blocks.

Engraved processes Copper engraving was the main method used to reproduce illustration in the 18th century. The artist's design is scored into a copper plate with a burin. After 1820 steel was also used because it was harder wearing, making longer print runs possible. It could take fine lines and extremely delicate, misty effects were achieved. As it was such hard work, the plates were often etched first and then the finer details engraved.

In the above three 'intaglio' processes the lines of the design are formed by indentations in the plate. The plate is inked, wiped clean and then printed under great pressure on to dampened paper, so that the paper is pressed into the inked indentations. The plates cannot be printed at the same time as the type which requires a different press.

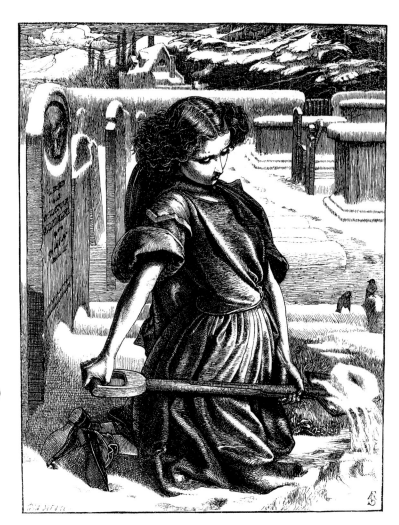

3 Frederick Sandys. *English sacred poetry*, 'The little mourner'. Sandys (1832–1904) was born in Norwich, the son of a dyer, and studied at a government school of design. He became a member of Rossetti's circle. He greatly admired the prints of Dürer and imitated his monogram. Wood engraving.

Wood engraving This was the most popular method of reproducing illustration in the Victorian era. In wood engraving, the parts of the design which are to be white are cut away, leaving the black parts in relief, capable of being printed at the same time as the text (for example **8**). The great achievement of the engraver Thomas Bewick (1753–1828) was the use of grey tones, produced by lowering parts of the block to print faintly. He used the close-grained end of boxwood, so was able to cut fine designs, but since box does not grow to a wide diameter, the designs were small. Later, blocks were glued together, but as the glue sometimes melted in steam processes, Charles Wells invented a way of bolting them together with recessed bolts. When a news periodical required a large picture in a hurry, several engravers could work on different blocks of the same picture. Such mass production, and the introduction of time-saving mechanical ruling to provide tone, spoiled the appearance of later 19th-century engravings.

The engraver interpreted the artist's drawing, some artists providing only a

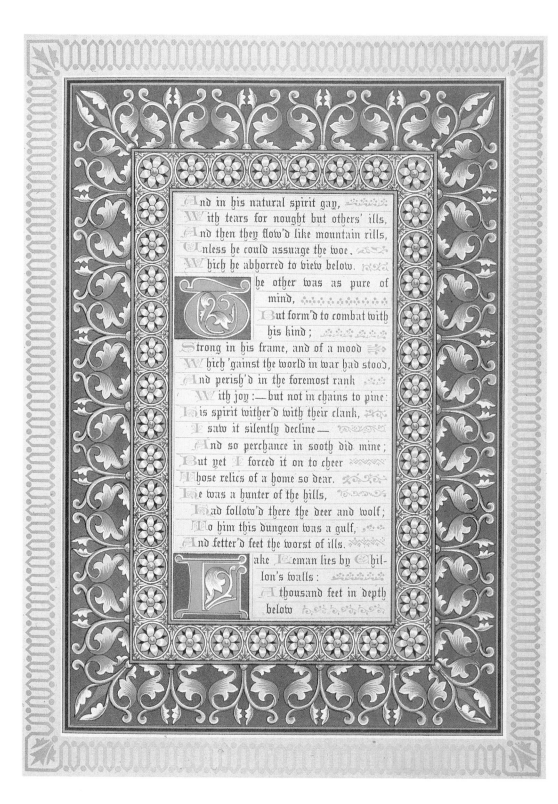

And in his natural spirit gay,
With tears for nought but others' ills,
And then they flow'd like mountain rills,
Unless he could assuage the woe,
Which he abhorred to view below.

The other was as pure of mind,
But form'd to combat with his kind;
Strong in his frame, and of a mood
Which 'gainst the world in war had stood,
And perish'd in the foremost rank
With joy:—but not in chains to pine:
His spirit wither'd with their clank,
I saw it silently decline—
And so perchance in sooth did mine;
But yet I forced it on to cheer
Those relics of a home so dear.
He was a hunter of the hills,
Had follow'd there the deer and wolf;
To him this dungeon was a gulf,
And fetter'd feet the worst of ills.

Lake Leman lies by Chillon's walls:
A thousand feet in depth below

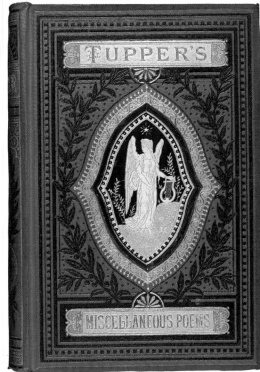

4 (*Opposite*): **W. & G. Audsley**, illuminators of George Gordon Byron's *The prisoner of Chillon* (1865).
[11651.m.8]
W.R. Tymms produced the brilliantly coloured and detailed chromolithographs for Day & Son, the publishers. The Audsleys, architects from Liverpool, seem to owe most to Italian Renaissance manuscripts for their decorative ideas.

5 *Left*: The cover of *Gems of great authors* (Gall & Inglis, 1881?). Reduced.
[11064.df.7]

6 *Right*: The cover of Martin Tupper's *Miscellaneous poems* (Gall & Inglis, 1881?). Reduced.
[11604.df.19]

sketch with a wash, so the finished product was very dependent on the skill of the engraver. Sometimes the wood-block was painted white and the artist drew on it in pencil, or his drawing was pasted on the block for the engraver to cut away. By the 1870s the design was often photographed on to the wood, and could be enlarged or reduced. From 1830, stereotypes could be cast in metal from the wood-block to give longer wear. These were superseded by electrotypes.

A well-known firm of wood engravers in the second half of the 19th century was that of the Brothers Dalziel at the Camden Press. George and Edward were later joined by another brother, John, and a sister, Margaret. They first collaborated with the Quaker publisher George Routledge, but their output grew so large they later used other publishers. George Dalziel had studied with a pupil of Bewick's. Ebenezer Landells, who engraved the earlier numbers of *Punch* and the *Illustrated London News*, was also Bewick's pupil. Joseph Swain took over from Landells as engraver of *Punch* and produced many book illustrations as well. William James Linton produced sensitive illustrations which emphasised the use of white rather than black lines. He was Rossetti's preferred engraver, but was dogged by misfortune and debt and emigrated to America where he was more successful.

Colour George Baxter patented a process in 1835 whereby he used 10 or more wood-blocks, one for each colour, to print on a toned outline produced

by aquatint. J.M. Kronheim took out a licence to work the process and was able to lower his costs so much that colour illustration could be used for inexpensive books. Edmund Evans combined cheapness with quality and taste and produced some of the finest colour books of the century, printing books by James and Richard Doyle, Kate Greenaway, Walter Crane and Randolph Caldecott.

Lithography Lithography, invented by Alois Senefelder, was brought to England in 1800. A design is drawn on limestone with greasy ink. The stone is dampened and water settles on the unmarked parts. The stone is then inked with greasy ink which is repelled by the water and only settles on the greasy areas. Paper is applied and the stone run through a press, printing from the greasy areas. Grained aluminium or zinc later replaced the stone, and these

7 The cover of William Falconer's *The shipwreck* (A. & C. Black, Edinburgh, 1868). [1347.h.7]
Bound by Leighton, Son & Hodge. Design probably by Noel Humphreys.

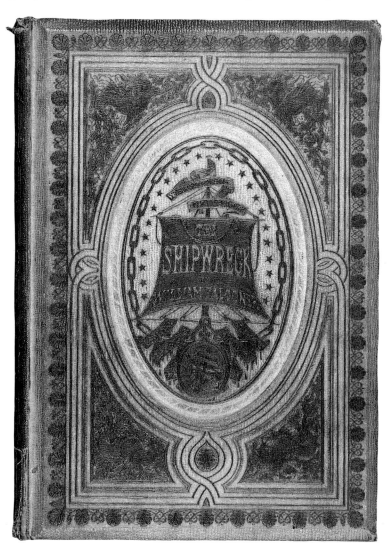

8 A.B. Houghton, illustrator of *Don Quixote* by Cervantes, translated by Charles Jarvis (Frederick Warne, 1866). [12490.h.2] 'Sancho embracing Dapple'. Despite his early death at the age of 39, Houghton produced a great many designs for the Dalziel brothers to engrave. He usually drew directly on the wood-block, capturing lively emotion, whether tender or humorous.

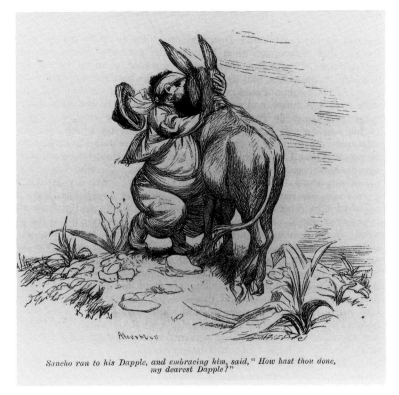

Sancho ran to his Dapple, and embracing him, said, " How hast thou done, my dearest Dapple?"

flexible plates could be wrapped round the cylinder of a rotary press. Early lithographs were often printed in a greyish tone and hand-coloured.

Charles Joseph Hullmandel (1789–1850) was the first noted English lithographer, William Day managing the business side for him. Hullmandel patented what he called the lithotint which imitated the washes of watercolours by printing a limited range of dilute colours, each from a different stone.

Godefroi Engelmann patented the process of full-colour printing by lithography, which he called 'chromolithography', in France in 1837. Thomas De la Rue patented a process for printing playing-cards in oil colours by lithography in 1832, but it was Owen Jones (1809–74) who exploited the process for book illustration. He sold an estate inherited from his father to set up a lithographic workshop in the Adelphi, and the first part of his *Plans, elevations, sections and details of the Alhambra* appeared in 1836, before Engelmann's patent. The parts continued until 1845 when the complete work came out at £36. 10s. At this stupendous price he did not sell enough copies to recoup his costs, but he went on to design and produce many other successful books and made such a name for himself that he was asked to design the interior colour scheme for the Great Exhibition.

Photographic processes Photography was used to copy designs for
wood engraving. It was later used in the 1890s in the new process of line-

9 Noel Humphreys.
Sentiments and similes of
Shakespeare (1851).
[C.30.g.6]
Moulded black papier mâché
cover with medallion in
terracotta.

blocks. In this process a photographic negative of the artist's drawing is projected on to a zinc plate coated with a light-sensitive emulsion. The light hardens the emulsion under the artist's lines. The rest of the emulsion is washed off and the lines hardened with resin. When the plate is etched, the lines remain in relief and can be printed at the same time as typeset text.

From the 1880s the halftone process was used to reproduce toned subjects. A cross-lined screen produced a pattern of evenly spaced dots of differing sizes to give an impression of tone.

Covers Until the 1820s books were sold in paper wrappers to be bound in full or half-leather as the customer required. The revolutionary idea of issuing books in cloth came from the young publisher William Pickering. The practice of casing was developed, probably by the binder Archibald Leighton: the cloth and boards were made up separately and the title and decoration added by gold blocking, before the case was glued to the book. The decoration, sometimes abstract and sometimes illustrative, became an art form in itself. The design in gold on the front was often repeated, either in gold or blind, on the back. Coloured paper panels were occasionally pasted on, and often themselves blocked in gold; and since binding was done in batches, according to demand, the same book often appears in different colour cloths. Fancy bindings were occasionally made in moulded papier-mâché coloured black to look like ebony, or in stamped leather (**5,6,7,9**). From the mid-1850s cheap editions of novels were given coloured, printed paper covers to catch the eye on railway bookstalls. They were nicknamed 'yellowbacks'.

10 (*Opposite*): The cover of
James Thomson's *Poetical*
works (W.P. Nimmo,
Edinburgh, 1868).
[11651,f.10]
Colour-printed paper inlay on
cloth.

Thomson's Poems

Illustrated

HEERE BIGYNNETH THE KNYGHTES TALE
IAMQUE DOMOS PATRIAS, SCITHICE POST ASPERA GENTIS PROELIA
LAURIGERO, et cetera (Stat. Theb. xii. 519.)

WHILOM, AS OLDE STORIES TELLEN US,
Ther was a duc that highte Theseus;
Of Atthenes he was lord and governour,
And in his tyme swich a conquerour,
That gretter was ther noon under the sonne.
ful many a riche contree hadde he wonne;
That with his wysdom and his chivalrye
He conquered al the regne of Femenye,
That whilom was ycleped Scithia;
And weddede the queene Ypolita,
And broghte hire hoom with hym in his contree
With muchel glorie and greet solempnytee,
And eek hir faire suster Emelye.
And thus with victorie and with melodye
Lete I this noble duc to Atthenes ryde,
And al his hoost, in armes hym bisyde.
And certes, if it nere to long to heere,
I wolde have toold yow fully the manere,
How wonnen was the regne of Femenye
By Theseus, and by his chivalrye;
And of the grete bataille for the nones
Bitwixen Atthenes and Amazones;
And how assegd was Ypolita,
The faire hardy queene of Scithia;
And of the feste that was at hir weddynge,
And of the tempest at hir hoom comynge;
But al that thyng I moot as now forbere.
I have, God woot, a large feeld to ere,
And wayke been the oxen in my plough.

Historical books

The second half of the 18th century saw a growing interest in serious historical research. Working from manuscripts in the British Museum, Joseph Strutt published *A complete view of the dress and habits of the People of England* (1796–99). He began an historical novel which was finished by Walter Scott. This presumably gave Scott the impetus to start his own career as an historical novelist with *Waverley* (1814). James Planché studied Strutt's work and advised on the costumes for a production of *King John* at Drury Lane in 1824, the first attempt to use authentic costumes for Shakespeare. In 1834 he published a *History of British costume*.

Popular interest was fired in all the picturesque aspects of the Middle Ages, from architecture and heraldry to the decorative arts. The *nouveaux riches* of Victorian society were eager to claim extinct titles or have new ones created and coats of arms drawn up, so that they could hang appropriate banners in the halls of their restored and Gothicised castles. Beyond the hall, the Gothic sometimes gave way to Jacobean or 18th-century French – the Victorians mixed historical styles in all their arts. Edward Bulwer Lytton, the author of *Rienzi* and *The last days of Pompeii*, inherited Knebworth, and smothered it with crenellations and towers. Lord Bute commissioned William Burges to remodel Cardiff Castle in the 1870s and then to build the Gothic fantasy Castell Coch nearby.

Henry Shaw (1800–73) was another student at the British Museum. In 1830 he published *Illuminated ornaments selected from manuscripts of the Middle Ages*. His most lavish work, *Dresses and decorations of the Middle Ages* was published in monthly parts at six shillings each in 1840, each part containing both hand-coloured etchings and coloured wood-block engravings. The complete work appeared in 1843 at seven guineas (**12,13**). Even more labour was lavished on *The arms of the colleges of Oxford*, published in 1855, in which the illustrations are hand-coloured with incredible precision on a lithographed outline (**17**).

Samuel Rush Meyrick provided another pictorial source for historical artists in his *Critical enquiry into antient armour* (1824). The Earl of Eglinton was so enthused by the romantic idea of medieval chivalry he had reproduction armour made for himself and his friends and organised a massive tournament at Eglinton Castle in August 1839. The enjoyment of the jousting and pageantry was marred by heavy rain which dripped down the backs of spectators sheltering in an inadequate marquee and spoiled the ball which was presided over by a Queen of Beauty, a jealously disputed post.

Joseph Nash, who trained under the architect Pugin the elder, catered for the nostalgia market with his *Mansions of England in the Olden time*, issued in parts from 1839 to 1849 (**16**). He drew rooms from great historic mansions which were still standing and peopled them with domestic scenes from appropriate ages in history, though the costumes of his characters were not always consistent with each other.

John Doyle, a political caricaturist, who signed himself 'H.B.', was the father of a talented family. Although it is his second son Richard who is best remembered today, his eldest son, James William Edmund (1822–92), distinguished himself as an historian and artist. His best known book was *A chronicle of England* (1864) which he illustrated with detailed pictures beautifully engraved and printed in colours by Edmund Evans (**21**).

11 (*Opposite*): **Sir Edward Burne-Jones.** *The works of Geoffrey Chaucer*, ornamented with pictures designed by Burne-Jones and engraved on wood by W.H. Hooper (Kelmscott Press, Hammersmith, 1896).
[C.43.h.19]

12 Henry Shaw. *Dresses and decorations of the Middle Ages* (W. Pickering, 1843).
Hand-coloured etching.

[2260.g.2]

13 Henry Shaw. *Dresses and decorations of the Middle Ages* (W. Pickering, 1843). Coloured wood engraving.

[2260.g.2]

engraved and printed in colours by Edmund Evans (**21**).

Walter Scott was the great populariser of medieval history, his works being widely read in Europe as well as in Great Britain. He studied Bishop Percy's *Reliques of Ancient English poetry*, a collection of ballads published in 1765, and as a result wrote several long narrative poems based on Scottish history, which were very successful at the time, but hard to read now. *The lay of the last minstrel* appeared in 1805, *Marmion* in 1808 and *The lady of the lake* in 1810.

In the footnotes of *Marmion* Scott refers to the main source of Arthurian legend, Malory's *Morte d'Arthur*, first published by Caxton in 1485. Scott prepared an edition which appeared in 1817 and was subsequently pored over by Tennyson and by Pre-Raphaelite artists. In 1837, Lady Charlotte Guest translated the *Mabinogion*, another Arthurian source. In 1842 Tennyson published a collection of poems which included 'Sir Galahad', the 'Morte d'Arthur' and 'The Lady of Shalott'. Edward Moxon republished the poems in 1857 with illustrations by Rossetti, Hunt and Millais, engraved by the Dalziels or W.J. Linton.

The Dalziels found Rossetti's coloured chalk drawings and washes difficult to interpret. He in turn claimed they had 'hewn his drawings to pieces' and preferred the work of W.J. Linton who engraved his illustration for 'Sir Galahad' (**14**). The Dalziels produced one of their most delicate and romantic works to interpret Millais's design for 'St Agnes Eve' (**15**). Tennyson's poem has no connection with Keats's, but describes the longing of a nun for purity as she looks out of her convent window on a snowy, star-filled night. Millais's young girl looks as if she is dreaming of her lover.

William Morris, the central figure of the Arts and Crafts movement, became friends with Edward Burne-Jones while at Exeter College, Oxford. Together they discovered the poetry of Tennyson and the beautiful Jane

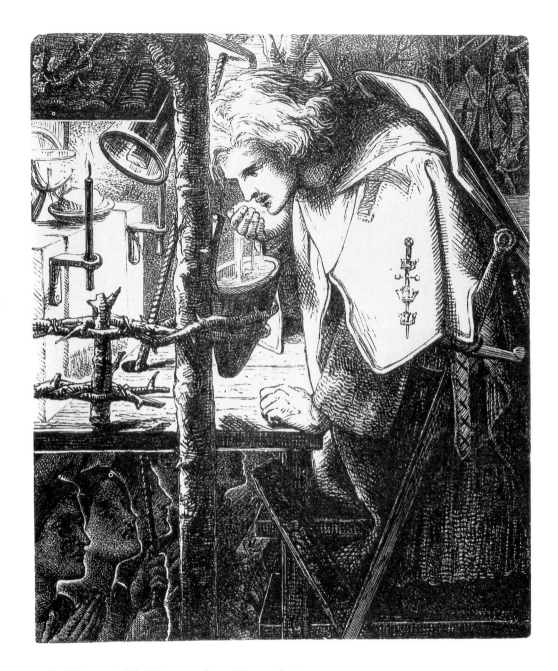

14 D.G. Rossetti. Alfred Tennyson, *Poems* (Moxon, 1857).
[11647.e.59]
'Sir Galahad'. Wood engraving.

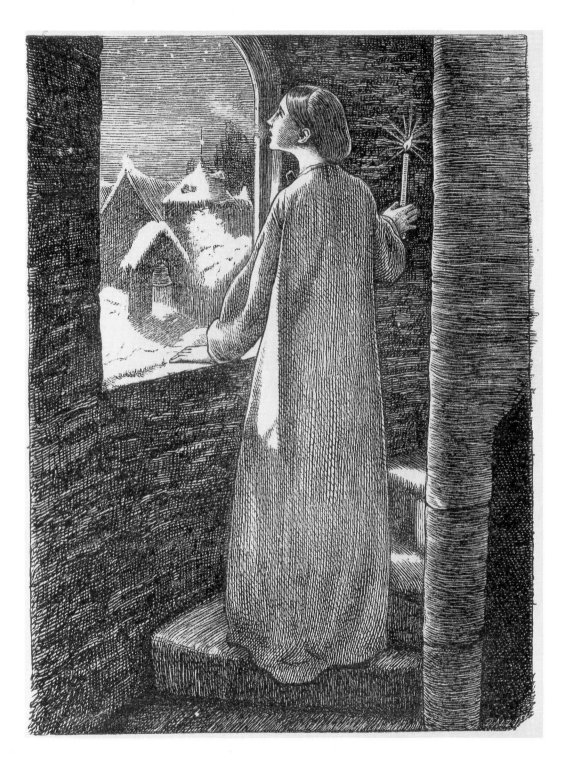

15 John Everett Millais. Alfred Tennyson, *Poems* (Moxon, 1857).
[11647.e.59]
'St Agnes Eve'. Wood engraving.

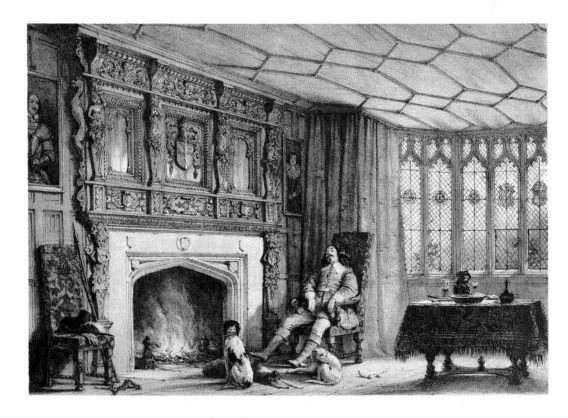

16 Joseph Nash. *The mansions of England in the olden time.* Southam, Glos. (T.M'Lean, 1839). [557*.h.17] Lithograph. Reduced.

17 (*Opposite*): **Henry Shaw.** *The arms of the colleges of Oxford* (Spiers & Son, Oxford, 1855). [9906.h.25] Hand-coloured lithograph of University College arms.

Burden, the daughter of a groom in a livery stable. Morris later married Jane, but did not make her happy. In 1856 Morris and Burne-Jones met Rossetti, who persuaded them both to take up painting. The next year they all collaborated, rather light-heartedly, in painting Arthurian subjects on the walls of the Oxford Union.

Morris did not prove as gifted a painter as Burne-Jones, but he excelled in the drawing of decorative patterns based on foliage which he used in the wallpapers and tapestries produced by his firm of Morris, Marshall, Faulkner and Co., founded in 1861. A later venture was the Kelmscott Press, launched in 1891 and named after Kelmscott Manor in Oxfordshire, of which Morris and Rossetti were joint tenants, Jane Morris living there with each in turn. Morris wanted to return to the glories of early printing and produced very expensive books, set and printed by hand on hand-made paper. His most famous production was the Kelmscott Chaucer (1896); the drawings were by Burne-Jones and the decorations by Morris (11).

J.M. Dent, the publisher, wanted to prove that fine medieval-style books could be produced by mechanical and photographic methods. He commissioned from the 20-year-old unknown, Aubrey Beardsley (1872–98), illustrations 'in the style of Burne-Jones' for an edition of Malory's *Morte d'Arthur* (19,20). Beardsley worked for two and a half years to produce 585 ornaments and 20 full-page illustrations. The theme is medieval, but the style is art nouveau, particularly in the floral borders, and the vignettes of satyrs and

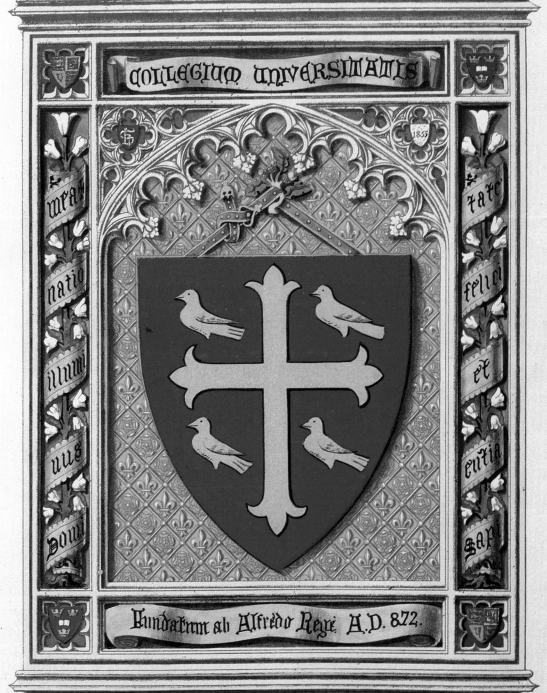

COLLEGIUM UNIVERSITATIS

Fundatum ab Alfredo Rege. A.D. 872.

BONITAS REGNABIT VERITAS LIBERABIT

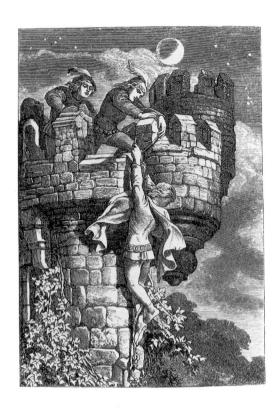

18 Daniel Maclise. Alfred Tennyson, *The princess*
(Moxon, 1860) [1859]
[1347.f.7]
Wood engraving.

19,20 Aubrey Beardsley Thomas Malory, *The birth,
life and acts of King Arthur ... embellished with designs by
Aubrey Beardsley*. Three volumes (Dent, 1893–94).
[K.T.C.19.a.11]
(*Right*): illustration from volume III, 'The sword
Excalibur is thrown back in to the lake on Arthur's
death'. (*Left*): Illustration of a faun. Line block.

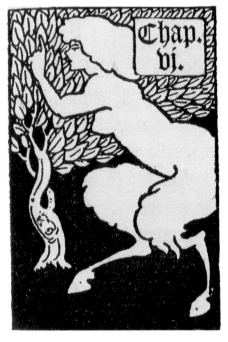

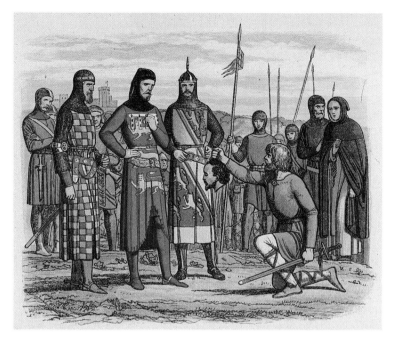

21 James E. Doyle. *A chronicle of England BC55–AD1485.* Illustrated by the author, engraved and printed by E. Evans (1864). [9503.h.3] Coloured wood engraving.

22 *(Page 25)*: **A.W.N. Pugin.** *A glossary of ecclesiastical ornament and costume* (Henry Bohn, 1844). [L.18.a.25] Chromolithographed by H.C. Maguire and printed by Michael Hanhart.

naked nymphs are distinctly decadent. Morris was so outraged at what he saw as a parody of his work that he threatened, but did not pursue, legal action. Death prevented him from publishing his own edition of Malory. Beardsley did not long survive him, dying of consumption in 1898 after a career of only seven years.

Tennyson wrote *The princess*, a tale in verse on the subject of female emancipation, in 1847. W.S. Gilbert used it as a basis for his libretto for *Princess Ida*. In 1860 Edward Moxon published an edition illustrated by the painter Daniel Maclise who was already famous for his large historical canvases and his work in the Houses of Parliament (18).

Religion

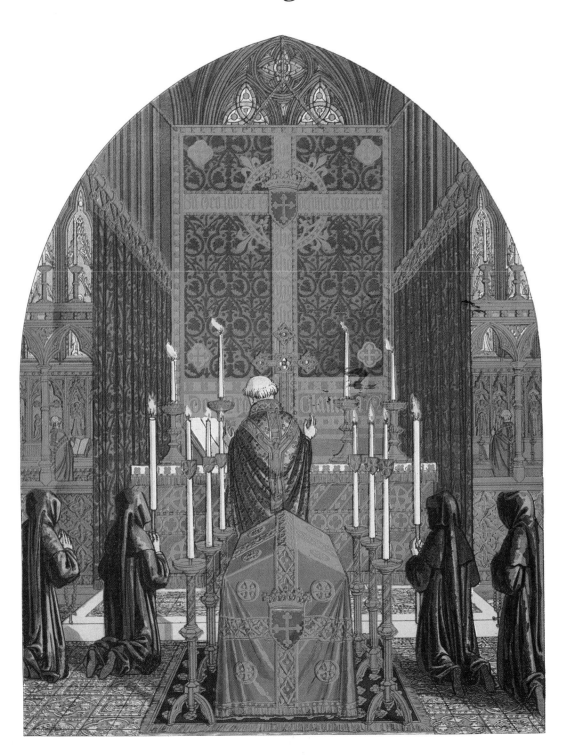

The 18th century in England saw a religious revival. John Wesley intended to reform the Anglican Church, but ended by establishing the Methodist sect. The Evangelical Revival at the end of the 18th century renewed the Anglican Church and inspired members to fight for social reform, for the abolition of slavery and for the conversion of the heathen at home and abroad. Robert Raikes, in founding Sunday schools to teach children to read the Bible, greatly increased working-class literacy and created a market for cheap moral literature.

If the Evangelicals were 'low' church, the Tractarians of Oxford (so called because they wrote 'Tracts for the times') were 'high'. They urged the importance of spirituality and liturgy, and they loved the historical, picturesque beauties of the Church. Henry Newman moved over to the Roman Church, but John Keble remained an Anglican, and his *Christian year*, a book of verse published in 1827, was frequently reprinted.

Augustus Welby Pugin (1812–52) designed rich interiors for the many new churches being built. He used stencilled decoration with plenty of red and gold, encaustic medieval-style tiles, rich hangings and gilded vaulting. He wanted to 'go on from where the Middle Ages left off'. He was so in love with the Gothic that his wife wore medieval dress, and he himself became a Roman Catholic since he believed that church closer to medieval tradition. His greatest achievement was the architectural detail and decorations (in fact people said most of the work) for the new Houses of Parliament under Sir Charles Barry. He published his *Glossary of ecclesiastical ornament* in 1844, the year of his second wife's death (**22**). His first wife died after only a year of marriage. Pugin himself was commited to Bedlam and died there at the age of 40.

At the cheap end of the book market were many improving tracts and serials illustrated with wood engravings, like the popular *Good words*. At the top end of the market were lavishly illustrated gift books of religious verse or paraphrases of the Bible, suitable for reading on a Sunday. Owen Jones and Noel Humphreys set a fashion for illumination as a hobby with their books *Illuminated books of the Middle Ages* (1844–49) and *The art of illumination and missal painting* (1849). Illuminated manuscripts were ideal for reproduction by chromolithography. Jones, who printed as well as designed the books, led the way in the printing of gold. Raw or burnt umber pigment was mixed with varnish and egg albumen and printed as a sticky ink on to which brass powder (copper and zinc) was dusted. Powdered silver, mixed with tin and lead, gave a silvery colour.

The two designers also worked separately. Noel Humphreys (1810–79) travelled in Italy and fell in love with the illuminated manuscripts he saw there. He was also a naturalist, as evidenced by his beautifully drawn flowers and insects. He produced many designs of delicate floral arabesques in black and white for verse anthologies, but his main achievements are his illuminated gift books, including *The miracles of Our Lord* (1848) and *Penitential psalms* (1861) which imitate the Flemish books of hours he admired in the British Museum collection (**26,28,32**). Unfortunately they are printed on thick card to fill out the volume, and the gutta-percha holding the cards together has often perished. The covers are black papier mâché moulded to look like carved ebony. At the back of the *Miracles* Humphreys writes that 'pictorial art

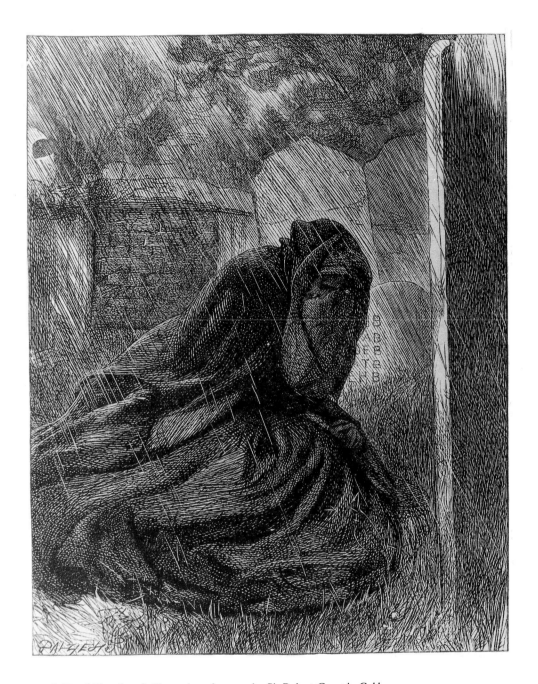

23 A. Boyd Houghton's illustration of a poem by Sir Robert Grant in *Golden thoughts from golden fountains* (F. Warne, 1867).
[11651.i.11]
'When sorrowing o'er some stone I bend
Which covers what was once a friend.'
Wood engraving.

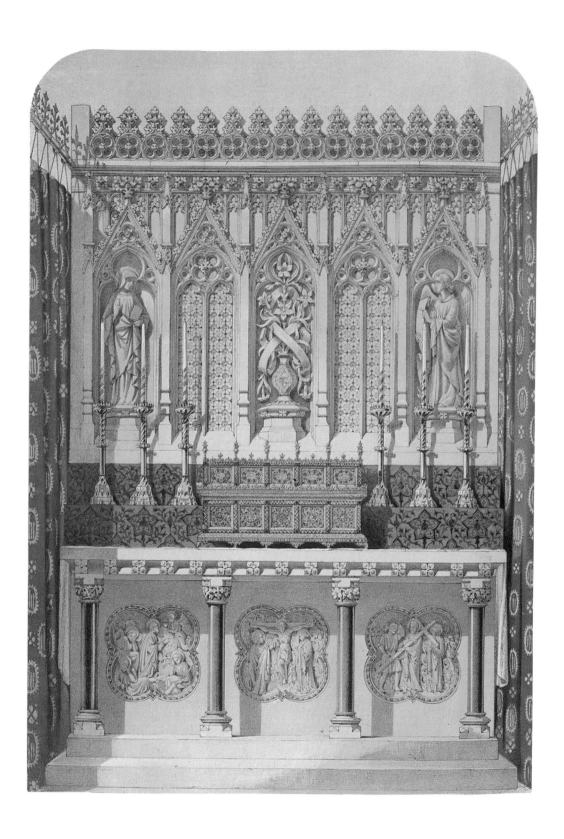

24 (*Opposite*):
A.W.N. Pugin's
design for Matthew
Digby Wyatt's *The
industrial arts of the
nineteenth century at
the Great Exhibition,
1851* (Day & Son,
1851).
[Tab. 1306.a]
Chromolithograph.

**25 Owen Jones
and Henry
Warren.** *The history
of Joseph and his
brethren* (Day &
Son, 1865).
[C.43.d.16]
'And Pharoah called
Joseph's name
Zaphenath.'
Chromolithograph.
Reduced.

**26 Noel
Humphreys.** *The
miracles of Our Lord*
(Longman, 1848).
[C.30.b.3]
Chromolithograph.
Reduced.

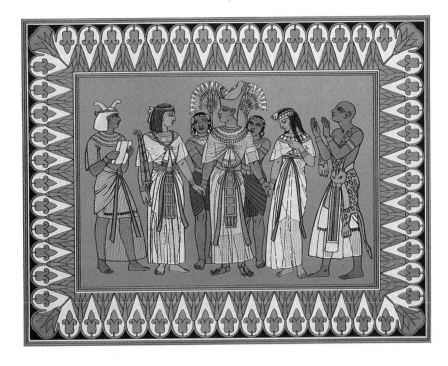

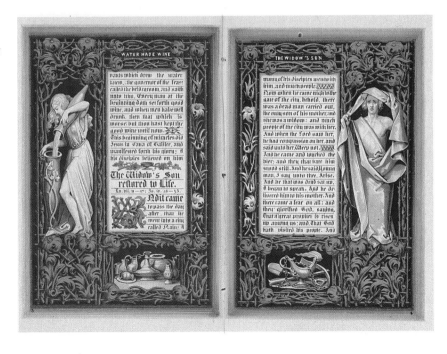

is often dismissed as Romanism', but Dr Arnold 'whose name is a sufficient guarantee for the soundness and liberality of his views' felt that 'pictorial art exercised a decidedly favourable influence on Christian feeling'. Some pages of the *Penitential psalms* copy the illusionistic late 15th-century Flemish school of illumination but alternate pages are in an earlier style leading to the jumble of styles so typical of Victorian art.

Owen Jones produced a number of more restrained books with foliated, gilded illumination on white, including a massive *Victoria psalter* (1861) with a moulded leather cover. He also produced some medium-sized books of bold, solidly coloured designs with 'oriental' details, gleaned from his travels in Moorish Spain and Egypt. The Egyptian motifs are evident in his *The history of Joseph and his brethren* (1865) (**25**).

The Dalziel brothers provided many engravings for verse anthologies. In 1867, however, they compiled one themselves on religious themes, *Golden thoughts from golden fountains* (**23**). Their own designs were outshone by those of Arthur Boyd Houghton (1836–75) who worked with them for many years, illustrating an *Arabian nights* among many other works. He was a prolific and speedy worker in spite of having lost the sight of one eye in a childhood accident. His troubles were not over, however; his wife died after only three years of marriage.

John Everett Millais (1829–96) was one of the most successful painters of the Victorian age, turning from his Pre-Raphaelite beginnings to safer society portraits and sentimental pictures. He also illustrated some of Trollope's novels and many periodical stories. He was happy to accept a commision from the Dalziels for 30 illustrations for *The Parables of Our Lord* in 1857 because he was to be the sole illustrator (**27**). The Dalziels usually commissioned drawings from a number of artists of varying ability for the sake of speed. Millais was pleased with the engravers' interpretations of his drawings and promised a regular supply. But by 1863 Effie Millais was writing apologetic letters on behalf of her husband who was 'too ashamed'. He considered the *Parables* to be 'finer work' than his painting, but was incapable of putting the painters (and commissions) aside for long enough to do them. Twelve designs were printed in *Good Words* and the Dalziels finally settled for 20 and published the *Parables* in 1864.

The brothers had a long-standing ambition to produce an illustrated Bible, but compromised in the end with a *Bible Gallery* of illustrations by Sir Edward Poynter, G.F. Watts and others, which they published in 1880. Millais promised his 'hearty cooperation', but produced nothing. Sir Frederick Leighton (1830–96) managed a number of powerful drawings in spite of finding the work 'trying on the eyes' (**29**). They show the influence of his former teacher Johann Steinle, a leader of the German Nazarene group who painted heroic biblical pictures.

Holman Hunt (1827–1910) was one of the few members of the Pre-Raphaelite Brotherhood to remain true to its principles, painstakingly producing immensely detailed religious works, working for years with ascetic determination on each picture. He illustrated two moral subjects for *Parables from nature* by Mrs Gatty (1864) (**31**).

27 John Everett Millais. *Parables of Our Lord* (Routledge, 1864).

[3226.f.24]

Illustration of Dives and Lazarus, engraved by the Brothers Dalziel.

28 Noel Humphreys. *The miracles of Our Lord* (Longman, 1848).
[C.30.b.3]
St Paul, after Martin Schoengauer, and St Matthias, holding a lance and the gospels, after Dürer.
Chromolithograph.

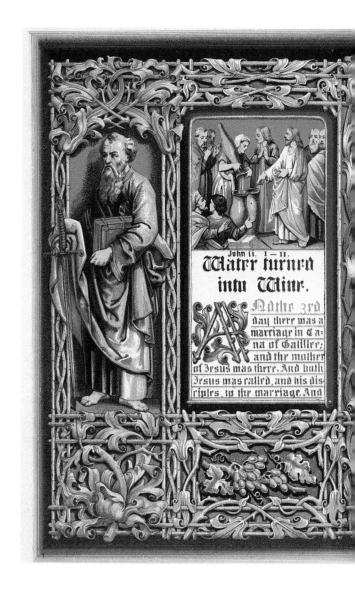

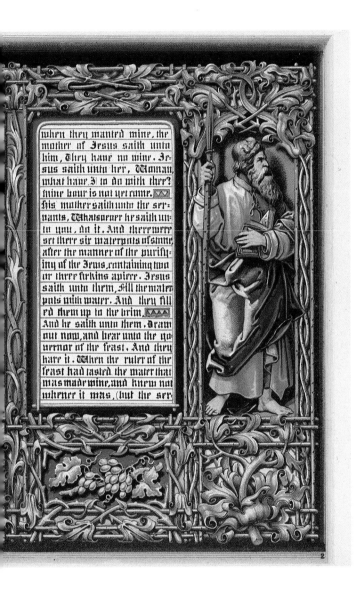

when they wanted wine, the
mother of Jesus saith unto
him, They have no wine. Je-
sus saith unto her, Woman,
what have I to do with thee?
mine hour is not yet come. ▽▽
His mother saith unto the ser-
vants, Whatsoever he saith un-
to you, do it. And there were
set there six waterpots of stone,
after the manner of the purify-
ing of the Jews, containing two
or three firkins apiece. Jesus
saith unto them, Fill the water-
pots with water. And they fill-
ed them up to the brim. ▽▽▽▽
And he saith unto them, Draw
out now, and bear unto the go-
vernor of the feast. And they
bare it. When the ruler of the
feast had tasted the water that
was made wine, and knew not
whence it was, (but the ser-

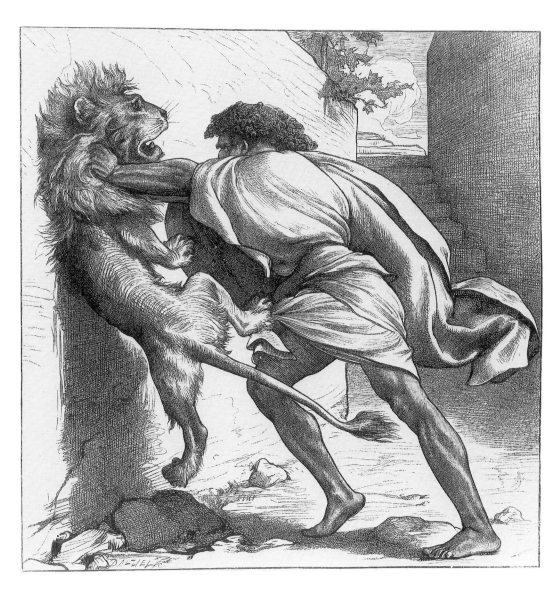

29 Frederick Leighton.
Dalziel's *Bible gallery* [1880].
[1261.d.25]
'Samson and the lion.' Wood
engraving.

30 (*Opposite, above*): **R.
Barnes's** illustration for Mrs
Barbauld's *Hymns in prose for
children* (John Murray, 1864).
[12807.cc.19]
This illustration reminds us
that the American Civil War
was still being fought in 1864
and the American slaves were
not yet free. Wood engraving.

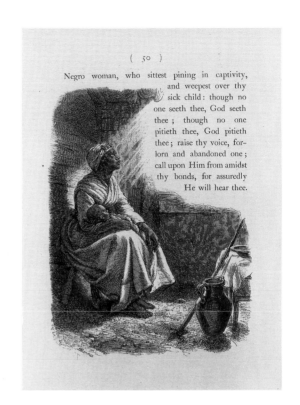

31 (*Below*): **Holman Hunt.**
Margaret Gatty's *Parables
from nature* (G. Bell & Sons,
new edition, 1880).
[12809.m.7]
A beautiful girl has learned
only 'accomplishments' and
does not know that the will o'
the wisp hovers over bogs and
is a warning of danger. She
thinks the light is her lover's
lantern and has fallen in the
marsh. Wood engraving.

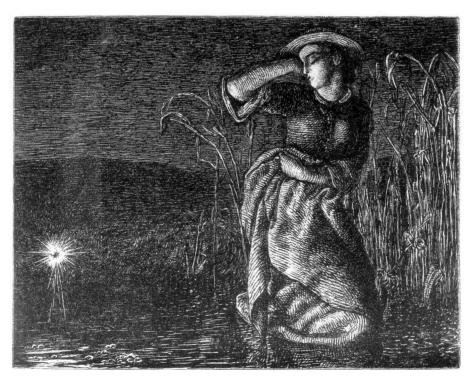

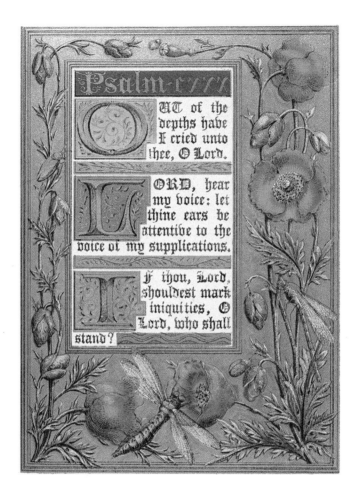

32 Noel Humphreys. *Penitential psalms* (no publisher known –
possibly Longman, 1861).
[C.44.c.4]
Chromolithograph. Reduced.

33 (*Opposite*): **W. & G. Audsley.** *The sermon on the mount* (Day &
Son, 1861).
[Tab.1216.a.]
Chromolithography by W.R. Tymms. Reduced.

St Matthew

Chapter v

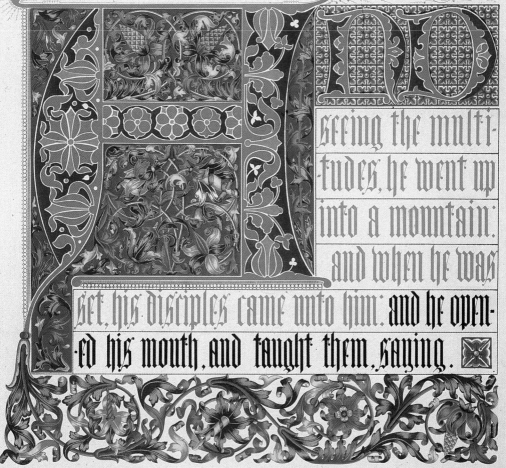

AND seeing the multitudes, he went up into a mountain: and when he was set, his disciples came unto him: and he opened his mouth, and taught them, saying.

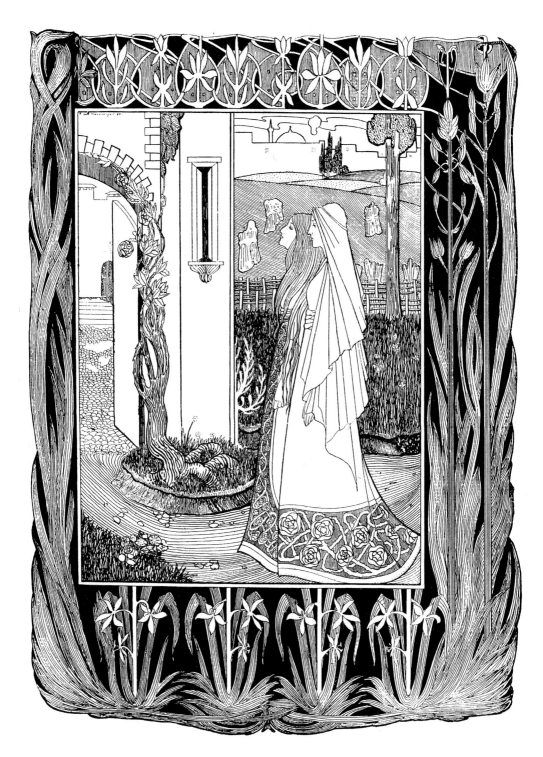

34 William B. Macdougal. *The Book of Ruth* (Dent, 1896).

[K.T.C.30.a.2.]

A decorative art nouveau style. Line block.

The world of nature

The Royal Botanic Gardens at Kew gained a considerable reputation during the reign of George III. Their unofficial director was Sir Joseph Banks, the botanist and explorer who left his collections, which included many books, to the British Museum. Kew was taken over by the State in 1841 and greatly enlarged. Its first official director was Sir William Jackson Hooker who sponsored expeditions to collect plants from around the world. Rich plant collectors also sponsored expeditions, or simply sent their head gardeners out to the East to collect exotic species for their hothouses. Robert Fortune swopped pages of *Punch* for tree seeds when collecting in China.

The Duke of Devonshire's Great Conservatory at Chatsworth was open to the public. His head gardener was Joseph Paxton, later Sir Joseph, after he designed the Crystal Palace. When a vast water-lily was seen in the Amazon basin botanists competed for its capture. Several attempts to raise it from seed or roots failed, but at last Hooker succeeded in raising three plants at Kew. He gave one to Paxton, one to the Duke of Northumberland at Syon, and kept one himself. Paxton won the race to get the plant to flower in 1849; the structure of its leaf was supposed to have inspired him to use metal ribs and glass in the Crystal Palace. Hooker published a book of lithographs by Kew's draughtsman Walter Hood Fitch (35). Two botanists independently named the lily *Victoria Regia* and *Victoria Regina*. It was then discovered that the species had already been named *Amazonica*, so the correct name should have been *Victoria Amazonica*, but this was thought to be unflattering to the Queen, and the name was suppressed until after her death.

Sir William's son Joseph Dalton (1817–91) succeeded his father as director of Kew. He went on several plant-hunting expeditions, including one to the Himalayas in 1848. He sketched rhododendrons and sent back seed in spite of difficulties with shortage of provisions, corrupt officials, insect bites, ticks and leeches which crawled up his legs by the hundred and even clung to his hair and eyelids. Fitch made lithographs from his sketches which were published in 1849 as *Rhododendrons of Sikkim-Himalaya* (36).

John Gould, the son of a gardener at Windsor Castle, began life in the same profession. Such was his skill at stuffing birds, however, he obtained the post of taxidermist at the Zoological Society in London. He obtained a large collection of bird skins from the Himalayas and drew plates for his first work *A century of birds from the Himalaya mountains*. Not being able to find a publisher he published this and 40 successive books himself, with considerable financial success. His *Birds of Asia* appeared in seven volumes from 1850 to 1883 (39).

Wordsworth had opened the eyes of his readers to the humbler beauties of the English countryside and many town-dwellers idealised the simple rustic life much as we do today. Albums of poetry and pictures were published depicting idyllic country scenes and simple pious country folk. The best country illustrators in black and white were G.J. Pinwell, J.W. North, F. Walker and the prolific Birket Foster who were all linked by friendship (37,40,41,45).

George John Pinwell (1842–75) was the son of a builder and received little formal education. He studied art at night, after a day as a delivery boy, and then worked for the engraver Whymper. He painted water-colours, and one

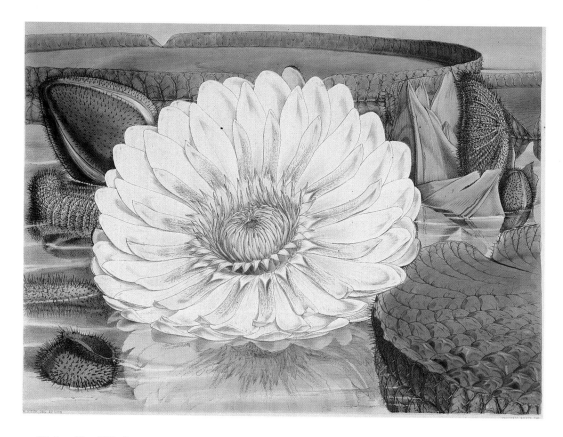

35 Walter Hood Fitch.
William Jackson Hooker,
*Victoria Regia; or Illustrations
of the Royal waterlily (1851)*
[Tab.1326.c]
Lithograph. Reduced.

36 (*Opposite*): **Walter Hood
Fitch.** Joseph Dalton Hooker,
*Rhododendrons of Sikkim-
Himalaya* (1849–51).
[1254.1.8]
Lithograph after a drawing by
Hooker.

of them attracted the attention of the Dalziels. They commissioned designs
from him for their illustrated Goldsmith (1865) and for their beautifully
engraved albums of rustic pictures, *Wayside posies* (1867), *Picture posies* (1874)
and others. His work also appeared in *Good words*. He died young of con-
sumption.

Other pupils of Whymper were J.W. North and Frederick Walker. Walker
(1840–75) struggled from a poor background to be apprenticed to an archi-
tect. He then attended the Academy schools before joining Whymper. His
style shows the influence of Millais, and he worked with increasing success for
Once a week, *Good words*, and the *Cornhill Magazine*. He too died of consump-
tion. John William North (1842–1924) was an excellent landscape artist and
produced some of the finest designs for the Dalziels' albums. He was lucky
enough to enjoy better health than his friends and lived and painted in
Somerset.

Myles Birket Foster (1825–99) was the most prolific of the Dalziels' coun-
try illustrators and an extremely successful painter in oils. He trained with
Ebenezer Landells the engraver, in whose workshop *Punch* and the *Illustrated
London News* were produced. Birket Foster's pictures show the influence of
Constable, with beautifully-drawn trees, thatched cottages, brooks and village
churches often framed in a lunette. His first success was the illustration of an
anthology of Longfellow's poems. Most of his work was in black and white,
but later works had delicate colours added to what were essentially line draw-
ings (**38,46**).

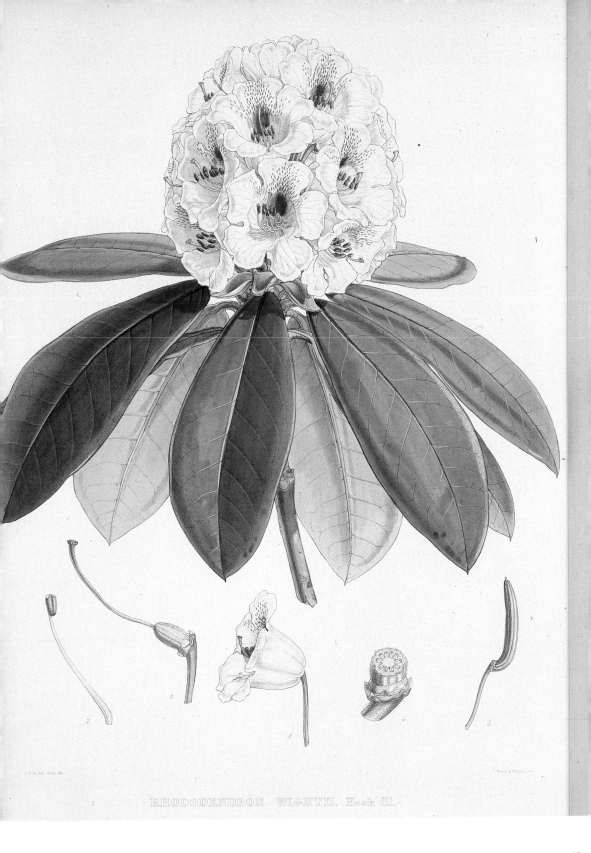

J.D.H. del. Fitch lith.

Davis & Nichols imp.

RHODODENDRON WIGHTII. Hook fil.

but later works had delicate colours added to what were essentially line drawings (**38,46**).

Birket Foster also drew sea scenes, often portraying ships in stormy weather. The Victorians admired the simple, brave folk who risked their lives at sea, like Dickens's Peggotty family. Henry Longfellow was perhaps the most widely-read poet of the 19th century, particularly for his religious verse, but his ballads 'Excelsior' and 'The wreck of the Hesperus' became classics of the parlour-song repertory. In the latter poem the skipper's small daughter is tied to the mast in a storm, and when the ship breaks up and all the crew are drowned, her body drifts ashore, still tied to the mast. Keeley Halswelle illustrated the scene in *Pen and pencil pictures from the poets*, 1866 (*see* Contents page).

Walter Crane (1846–1915) was apprenticed to W.J. Linton, the engraver. He showed an early talent for depicting animals and was given the task of preparing drawings for an encyclopaedia. The British Museum Reading Room was a favourite place of study. He liked the early printed herbals and copied their bold style. In 1863 he met Edmund Evans and worked with him to produce children's books and designs for 'yellowback' covers. Evans printed *Flora's feast*, the first and most popular of a series of flower books in 1889 (**47**). Crane may have taken the idea of giving characters to flowers from Grandville's *Les fleurs animés*. His work embodies the 'aesthetic' look of the 1890s.

37 George John Pinwell. *Wayside posies.* ed. Robert Buchanan, engraved by the Dalziel brothers (Routledge, 1867).
[11651.k.8]
'Shadow and Substance'.
'Nell stands by the stream, and her shadow glimmers below.'
Wood engraving.

38 Birket Foster. *Odes and sonnets* (1859).
[1347.g.11]
Printed by the Dalziels. Coloured wood engraving.

39 (*Opposite*): **John Gould.** *The birds of Asia* (1853–83).
[462*.e.3]
Volume 1, *Actenoides Lindsayi*. Lithograph

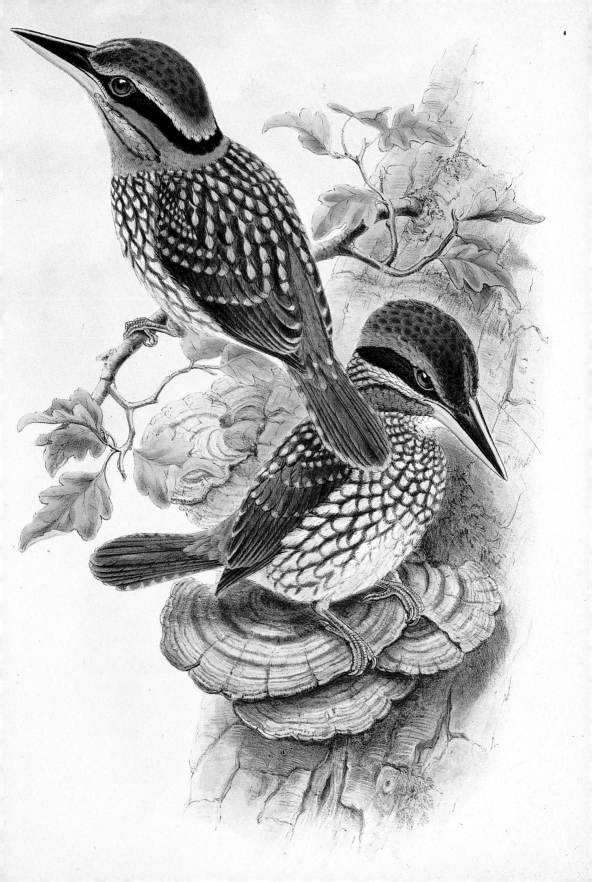

40 (*Opposite*): **John William North.** *Wayside posies*, 'On the shore'.
'The dim line where mingle heaven and ocean
While fishing boats lie nestling in the grey.'
Wood engraving.
41 John William North. *Wayside posies*, 'Reaping'.
'The young hares are feasting on nectar of dew'.
Wood engraving.

42 Walter Severn. *The golden calendar* (Day &
Son, [1865]).

[754.c.13]

Chromolithography, etching and letterpress have
been skilfully combined on one page.

43 (*Opposite*): **A.F.Lydon** *Fairy Mary's dream*
(Groombridge & Sons, 1870).

[11651.i.19]

Illustrated by the author and printed in colours
from wood by Benjamin Fawcett.

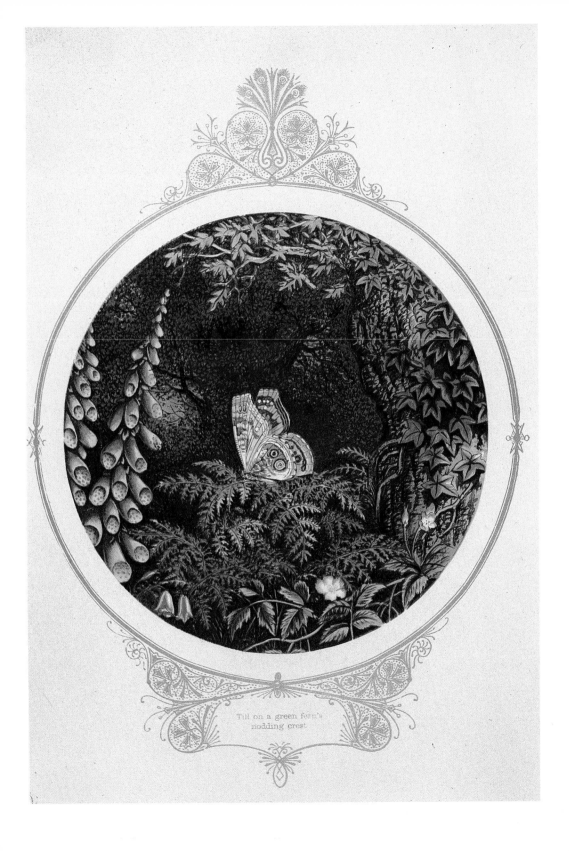

Till on a green fern's
nodding crest

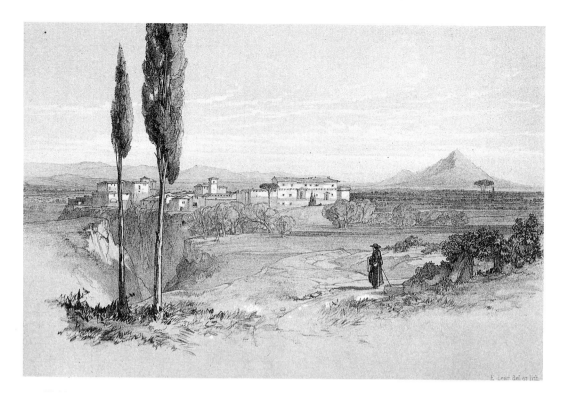

44 Edward Lear. *Illustrated excursions in Italy* (Thomas M'Lean, 18.6).
[1263.g.22]
Volume II Gallese; lithotint.
Edward Lear was born in 1812, the 20th of 21 children. A self-taught artist, his
career began with superb ornithological studies which set the standard for John
Gould. Epilepsy and fits of depression may have prompted him to avoid society
and take to travel and landscape painting. From 1837 to 1848 he lived in Rome,
selling paintings to the English community. In 1842 he travelled in the Abruzzi,
and from his water-colours prepared lithographs for *Illustrated excursions in Italy*.
Queen Victoria was so impressed by the first volume, she asked Lear to give her
drawing lessons. The second volume carried an advertisement for his *Book of
Nonsense*, but only under the pseudonym 'Old Derry down Derry'. His
authorship was not acknowledged until the third edition of 1861.

45 (*Opposite*): **Frederick Walker.** *Wayside Posies.*
'And in her changeful path the wind
Blows the wild shadows of the rain.'
Wood engraving.

46 Birket Foster. *Christmas with the poets* (1851).
[1347.1.23]
Printed by H.J. Vizetelly.
Coloured wood engraving.

47 (*Opposite*): **Walter Crane.** *Flora's feast* (Cassell & Co., 1889).
[11651.1.21]
The sunflower was a favourite decorative motif for artists of the Aesthetic
movement. Coloured wood engraving.

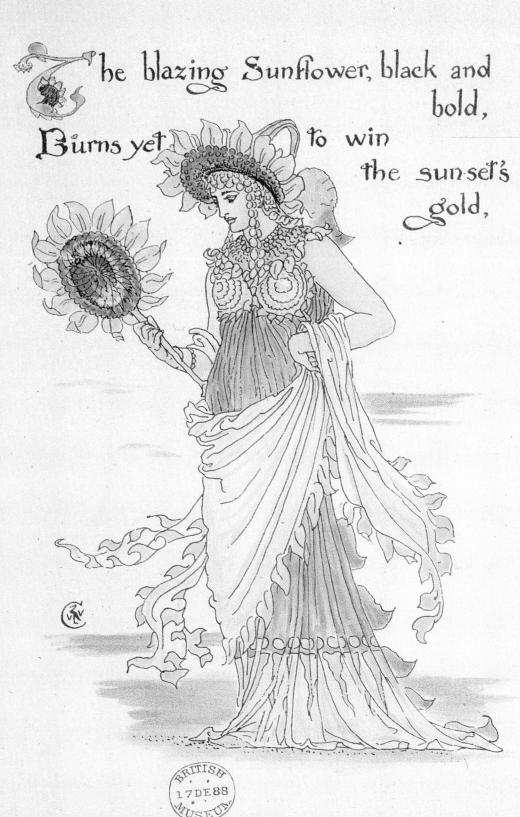

The blazing Sunflower, black and
bold,
Burns yet to win
the sunset's
gold,

36

The Orient, fantasy and the fairy world

Napoleon was perhaps the founder of Egyptian studies, for he took scholars with him on his expedition of 1789. His campaign was a military failure, but an artistic success, in that it set the fashion for the Egyptian style, in furniture and interior decoration. After their defeat by the British, the French had to hand over the antiquities they had gathered, and the artefacts, which included the Rosetta stone, were sent to the British Museum. Fifteen years later Giovanni Battista Belzoni added to this collection and arranged his own popular exhibition in the Egyptian Hall, Piccadilly.

David Roberts (1796–1864) was to show the public the romantic settings of the massive stone statues which had aroused so much interest. Roberts came from a poor family, but Bible stories had inspired him with a desire to travel. His first journey was only as far as Spain. In 1838 he went to Egypt where he sailed down the Nile and was 'overcome with melancholy reflections on the mutability of all human greatness'. His sketches show the romantic grandeur of the monuments, complete with picturesque costumed natives to demonstrate the immense scale of the ruins. He also achieved his dearest ambition to visit the Holy Land. On his return home he solicited subscribers, including the Queen, to pay the costs of the five-volume *The Holy Land, Syria, Idumea, Arabia, Egypt & Nubia* (1842–9) in which his sketches were turned into lithographs by Louis Haghe (**50**).

Owen Jones visited the Alhambra in Granada with his friend Jules Goury,

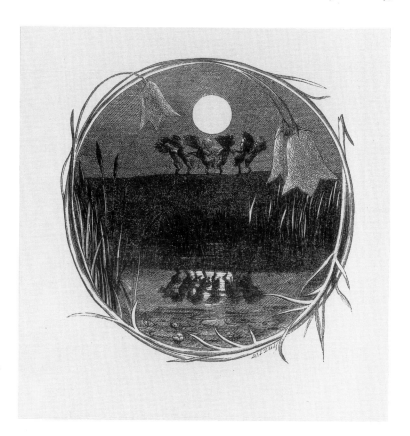

48 Arthur Hughes's illustration for William Allingham's *The music master* (Routledge, 1855).
[C.58.b.21]
Wood engraving.

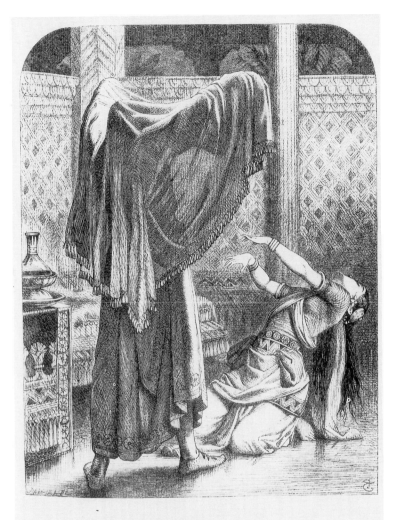

"Here—judge if hell, with all its power to damn,
"Can add one curse to the foul thing I am!"

49 John Tenniel's
illustration for Thomas
Moore, *Lallah Rookh*
(Longman, 1861).
The prophet of Khorassan
wears a veil to hide his
hideous face. When he raises it
the maid Zelica faints. Wood
engraving.

who died there of cholera. Jones brought back detailed drawings and casts and
from them printed his *Details and ornaments from the Alhambra*. The illustra-
tions were architecturally precise, detailed and colourful, and were no doubt a
useful source for other illustrators of 'oriental' themes (**51**).

Byron set a fashion for oriental romances featuring dark-eyed maidens and
violent action amid dramatic scenery. Painters and engravers loved portraying
doe-eyed oriental maidens, a Victorian gentleman's erotic ideal, no doubt.
Thomas Moore, the Irish poet, wrote songs on Irish themes such as 'The
minstrel boy' but his most successful single poem was a Byronic imitation,
'Lallah Rookh; an Oriental romance' (1817) which ran to many editions (**49**).

The Dalziels produced one in 1863 with designs by Sir John Tenniel, the
Punch artist and illustrator of the *Alice* books. Moore followed up his success
with 'Paradise and the peri'. Owen Jones produced an illuminated version of
this poem in 1860 (**51**).

The 'oriental' provided one popular visual fantasy world; fairyland pro-
vided another. Fairy paintings and illustrations abounded, and, of course, they
were always popular on the stage. The craze was satirized by W.S. Gilbert in
his libretto for *Iolanthe*.

Richard (Dicky) Doyle (1824–83) worked on the staff of *Punch* for seven
years, before resigning in protest at the editor's anti-Catholic campaign,
Doyle being an Irish Catholic himself. He turned to book illustration, particu-
larly working on fairy books. His masterpiece was *In Fairyland; a series of
pictures from the Elf world.* (1870) (**60**). Edmund Evans first produced proofs
of the outline which Doyle hand-coloured. Using wood-blocks Evans repro-

52 Henry Holiday. Lewis Carroll, *The hunting of the snark: an agony in eight fits* (Macmillan, 1876).

[11646.d.66]

'The Beaver's lesson'. Wood engraving.

duced the colours with great accuracy, producing perhaps the finest book of his career. William Allingham had to write verse to fit the pictures; it is hardly surprising the lines are uninspired.

Allingham also wrote a collection of verse entitled *Day and night songs*. A second edition with additional poems was published as *The music master* (**48**) with illustrations by Rossetti and Alfred Hughes. Hughes (1832–95) worked with Rossetti and Morris on the Oxford Union frescoes, and was converted to the Pre-Raphaelite gospel by them, producing sentimental pictures like 'April love', and 'The long engagement'. His fairies are better drawn than his people, who tend to look willowy and unconvincing.

Sir John Gilbert (1817–97) was amazingly prolific, illustrating many verse

anthologies, and producing nearly 30,000 drawings for the *Illustrated London News*. He was famous as an artist, but his paintings are forgotten now. Some of his work was dramatic and lively, like the illustration of a sinister elf in Adam and Charles Black's edition of Scott's *The lay of the last minstrel* (1854) (53).

Lewis Carroll's most famous illustrator was Sir John Tenniel, but another artist, Henry Holiday (1839–1927) produced nine delightfully nightmarish designs for *The hunting of the Snark* (Macmillan, 1876) which were engraved by Joseph Swain (52). Holiday was a friend of Rossetti, and his most famous

53 John Gilbert. Walter Scott, *The lay of the last minstrel* (A. & C. Black, 1854). An elf, having assumed the shape of a child, flees from Watt Tinlinn, an archer, who shoots him. The elf, resuming his own shape is unharmed. Wood engraving.

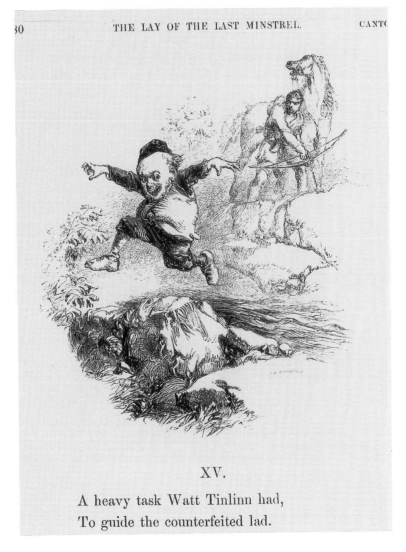

30 THE LAY OF THE LAST MINSTREL. CANTO

XV.

A heavy task Watt Tinlinn had,
To guide the counterfeited lad.

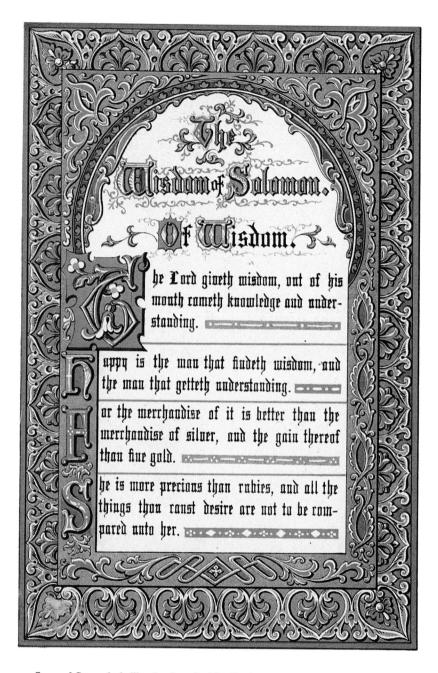

54 Samuel Stanesby's illuminations for *The Wisdom of Solomon*, (1861).
[C.129.d.7]
Chromolithograph.

55 *The pictorial album*, or
Cabinet of paintings (Chapman
& Hall, 1837).

[C.70.g.3]

Printed by George Baxter.
'Zenobia'. Coloured wood-
blocks on a steel engraving
after a painting by Wm
Pickersgill, RA. The first
popular illustrated book to be
printed in colours.

painting, 'Dante and Beatrice' was a tribute to Rossetti's preoccupation with
Dante. Holiday taught at South Kensington and designed stained glass.

W.T. Horton (1864–1919) produced some striking and original pictures in
his *Book of images* (1898) (*see* inside back cover). W.B. Yeats explains in his
introduction that Horton was a disciple of the 'Brotherhood of the new
life... which finds the way to God in waking dreams', and was 'the most
medieval in modern mysticism'. Some of his pictures are of religious images,
and some show silhouettes of medieval turrets 'made spectral' said Horton, to
make him feel 'all things but a waking dream'. Yeats dubbed his art 'the
reverie of a lonely and profound temperament'.

Robert Anning Bell (1863–1933) was an apprentice in an architect's office
before studying at the Royal Academy schools. Much of his illustrative work
is based on the flat, Renaissance style of drawing seen in the *Hypnerotomachia
Poliphili* printed in Venice in 1499, which he much admired. He taught at
Liverpool University, and later at Glasgow School of Art which became a
significant centre of artistic and architectural design at the turn of the century.

Scratching their heads as if they itched.

56 Charles Brock. J.C. Atkinson, *Scenes in fairyland* (Macmillan, 1892).
[012807.ee.38]
Line block.

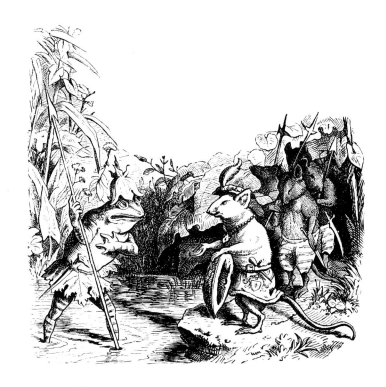

57 G.S. C.L. Mateaux, *Woodland romances* (Cassell, Petter & Galpin [1877]).
[11651.f.1]
'Battle of frogs and mice.'
Wood engraving.

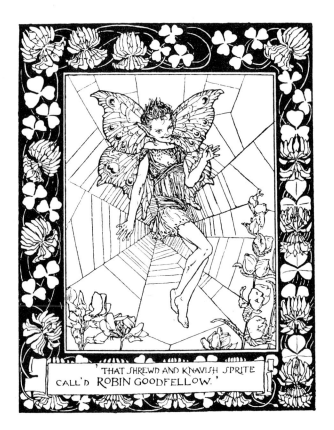

'THAT SHREWD AND KNAVISH SPRITE
CALL'D ROBIN GOODFELLOW.'

58 R. Anning Bell. William Shakespeare, *A midsummer night's dream* (J.M. Dent, 1895).
[K.T.C.35.a.7]
'Robin Goodfellow'. Line block.

59 Laurence Housman. Christina Rossetti's *Goblin market* (Macmillan, 1893).
[11647.f.33]
Line block.

Bell designed the book as a whole, with an artistically laid-out text and decorative borders printed on hand-made paper. His *Midsummer Night's Dream* was published in 1895 (**58** and title verso).

Laurence Housman (1865–1959) took similar care with the complete design of a book. He was the brother of the poet A.E. Housman, and their sister also achieved some fame as a wood engraver and writer of fiction. Laurence wanted to write, but found it easier to make a living out of book illustration. His first success was George Meredith's *Jump-to-Glory Jane* (1892). His sinister illustrations to Christina Rossetti's *Goblin Market* (**59**) owe something to the art of her brother Dante Gabriel. Their dense, convoluted designs are balanced against whiter pages on which a few lines of verse are interspersed with delicate drawings reminiscent of the paintings of Samuel Palmer. Housman gave up book illustration after only ten years because he achieved increasing success as a writer.

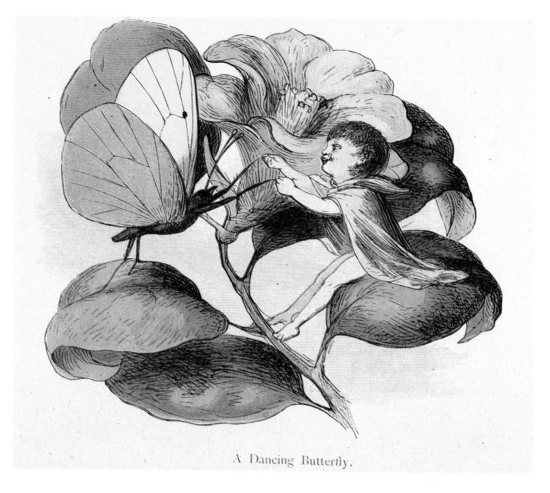

A Dancing Butterfly.

60 Richard Doyle. *In fairyland; a series of pictures from the Elf world* (Longman, 1870).

[1876.e.18]

Illustrated by the author. Coloured wood engraving.

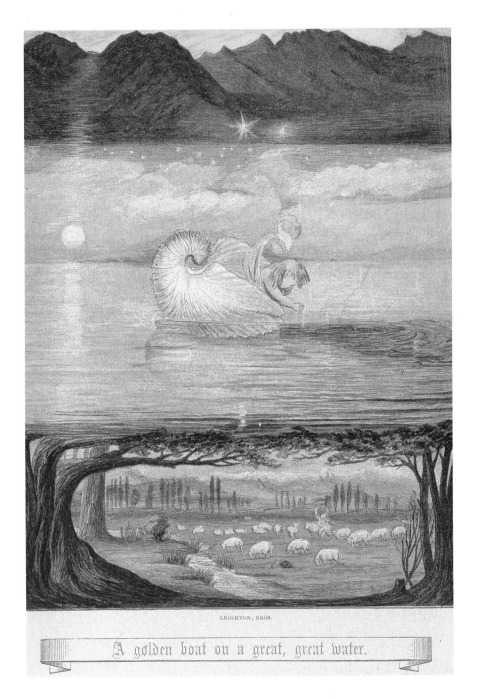

LEIGHTON, BROS.

A golden boat on a great, great water.

61 Eleanor Vere Boyle. Sarah Austin, *Story without an end*. Printed by G.C. Leighton.
[12806.h.49]
Eleanor Vere Boyle was the only noted woman illustrator of the 1860s, wife of the Queen's chaplain. This illustration perhaps owes its design to Blake. Coloured wood engraving.

page 197

The social world

The early popularity of Charles Dickens was greatly enhanced by his illustrators. The publishers Chapman & Hall were looking for someone to write a novel around a series of illustrations to be drawn by R.S. Seymour, the popular sporting artist. They picked Charles Dickens, then 23, and already known as a journalist and author of periodical sketches. The title *The adventures of the Nimrod Club* was suggested. Dickens proved less pliable than hoped. He jettisoned Seymour's idea of a tall, thin sporting hero, and decided on a comic, plump Londoner whom he called Pickwick (**62**).

On 20 April 1836, having drawn seven plates, Seymour committed suicide. Another artist, R.S. Buss, proved unsatisfactory, and Dickens likewise rejected the offerings of Thackeray and John Leech. Dickens chose the 20-year-old Hablot Knight Browne, whom he felt he could dominate. Browne abandoned his first pen-name 'Nemo' for 'Phiz' to match the name 'Boz' used by Dickens. Dickens introduced a new character, Sam Weller, who was portrayed with great liveliness by 'Phiz' and soon 40,000 copies of each issue were being sold and a great partnership was formed.

At the same time, however, Dickens was working with another much older artist. George Cruikshank (1792–1878) had made his reputation during the Regency with his satirical cartoons, and with the characters Tom and Jerry, two Regency rakes who figured in Pierce Egan's *Life in London*. He was commissioned by Macrone, the publisher, to illustrate some collected pieces by Dickens which were published under the title *Sketches by Boz*. Dickens was then given the job of editing a new magazine *Bentley's Miscellany*, by the owner Richard Bentley. Part of the contract was the provision of a novel, and Dickens began to issue *Oliver Twist* from February 1837, with a plate by Cruikshank for each instalment (**65,66**). Unfortnately Dickens and Cruikshank fell out over the last plate and never collaborated again.

The success in Paris of the humorous periodical *Charivari*, begun in 1832, tempted Henry Mayhew, a journalist, Joseph Last, a printer, and Ebenezer Landells, an engraver, to attempt an imitation in 1841, which they called *Punch*. Despite poor illustrations, it was moderately successful, but not enough to break even. It was taken over by one of its unpaid printers, Bradbury and Evans, and Mark Lemon became the editor. Thackeray and Douglas Jerrold joined the staff.

Richard Doyle learned how to draw on wood from Joseph Swain, now *Punch*'s engraver, and joined the staff in 1843 at the age of only 19. He shared the weekly political cartoon with John Leech, but social cartoons were his forte. 'Ye manners & customs of ye Englyshe', rather crowded pictures of society, were very successful. He then created a comic trio of bachelors-about-town, Brown, Jones and Robinson, whose attempts to break into fashionable London society are foiled by disasters. A successful album *The foreign tour of Brown, Jones & Robinson* (1854) was based on Doyle's own trip abroad with two friends from Punch (**67,68**).

The artist who personified *Punch* however was John Leech. His father had run a coffee-house on Ludgate Hill before going bankrupt, and Leech soon learned to draw the characters who flocked there. Nearby were the great coaching inns and Leech developed a passion for horses. Later in life his enthusiasm for hunting strained his resources considerably. His drawings

62 'Phiz'. Charles Dickens, *The Pickwick Papers* (Chapman & Hall, 1837). [C.58.f.20] Pickwick, having fallen into a drunken sleep in the wheelbarrow in which he was being conveyed, wakes up in the village pound. Etching.

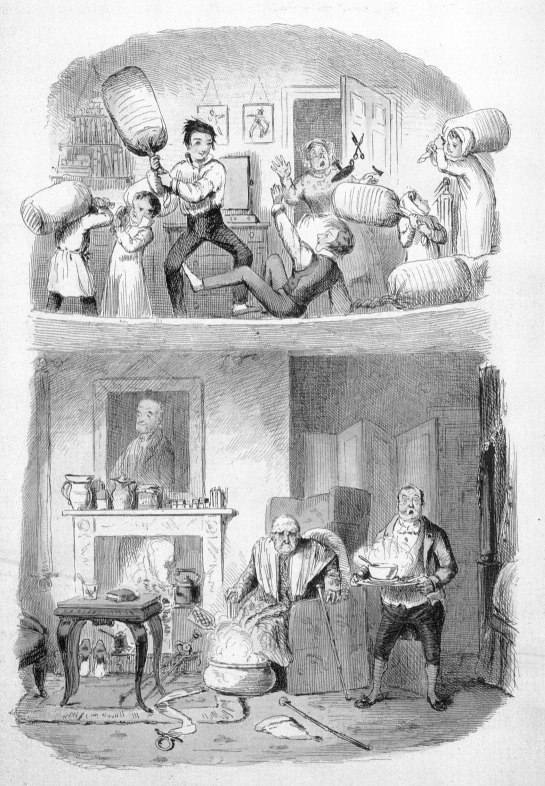

over the head of M.ʳ Wormwood Scrubbs.

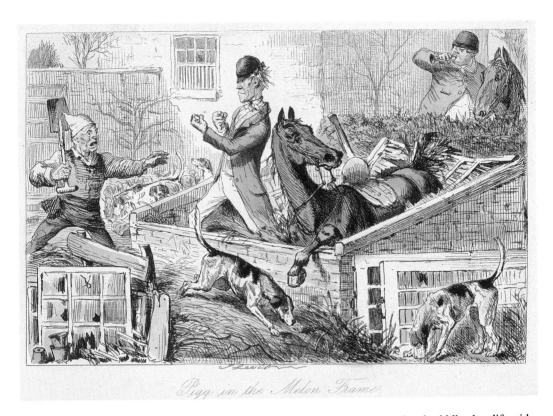

Pigg in the Melon Frame.

64 John Leech. R.S. Surtees,
*Handley Cross, or, Mr
Jorrocks's hunt* (1854).
[C.70.d.3]
'Pigg in the melon frame.'
Hand-coloured etching.

earned him enough to settle down to a conventional middle-class life with a
pretty wife whom he frequently portrayed. He depicted the small problems of
middle-class life, beginning with a series of *Domestic bliss* portraying a helpless
wife and a tormented husband. *Flunkeiana* and *Servantgalism* depicted the
snobbery and insubordination of servants. The arrival of Leech's children
prompted *The rising generation* and a book, *Young Troublesome, or Master
Jacky's holidays* (**63**).

Leech gave himself a chance to draw horses when he invented the character
of Mr Briggs, an accident-prone rider to hounds. Robert Surtees, a sporting
journalist, created the figure of Jorrocks in the *New sporting magazine* and
wrote a novel around him in 1843, *Handley Cross or Mr Jorrocks' hunt*. Leech
was suggested as illustrator, but he asked for six guineas a picture, and the
cheaper 'Phiz' won the commission. However, after the success of Leech's
pictures for *Mr Sponge's sporting tour* in 1849, he was chosen to illustrate a
new edition of *Handley Cross* (**64**). Of Mr Sponge, Leech had written: 'Red is
a very taking colour with our craft . . . I think it will be as well to have as many
hunting (scenes) as we can'. The red paint was liberally applied for Mr
Jorrocks.

Leech was a friend of Thackeray's from his schooldays at Charterhouse.
Thackeray had started his career as a journalist and then tried to make a living
as a painter in Paris. Having acquired a wife to support he had to return to
London for a steadier income from writing, first for *Fraser's magazine* and
then for *Punch*. He illustrated most of his articles as he did his greatest novel

63 (*Opposite*): **John Leech**
*Young troublesome, or, Master
Jacky's holidays* (1850).
[1899.c.42]
Hand-coloured etching.

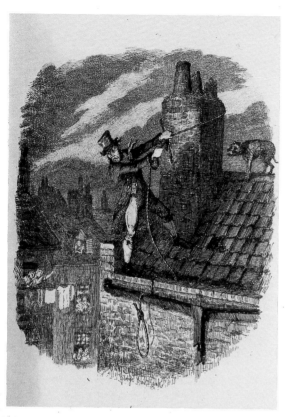

65 George Cruikshank. Charles Dickens, *Oliver Twist* (Richard Bentley, 1838). [C.131.d.26] 'The last chance, Bill Sykes.' Etching.

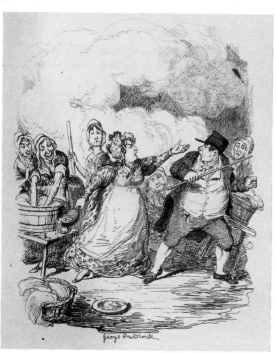

66 George Cruikshank. Charles Dickens, *Oliver Twist* (Richard Bentley, 1838). [C.131.d.26] 'Mr Bumble degraded in the eyes of the paupers.' Etching.

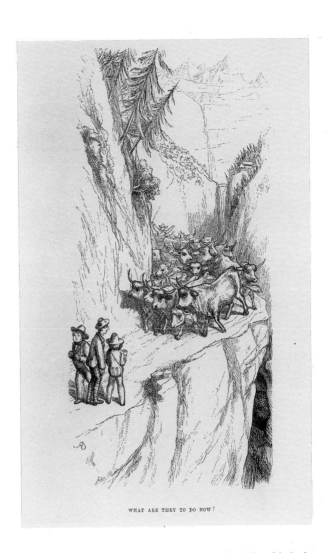

WHAT ARE THEY TO DO NOW?

67 Richard Doyle. *The foreign tour of Brown, Jones & Robinson* (Bradbury & Evans, 1854).
[559*.d.20]
Wood engraving.

Vanity Fair, published in parts from 1847 to 1848 (**70**). In 1860 he became the first editor of the *Cornhill Magazine* and gave kindly encouragement to young artists like Frederick Walker, who redrew Thackeray's rather weak illustrations for his novel *The adventures of Philip*.

William Schwenk Gilbert was another author–illustrator. He earned his living by the law, but in 1861 began to contribute comic verse to *Fun* magazine. He used the pseudonym 'Bab' and the collected verse was published in 1869 as the *Bab ballads* with illustrations by the author (**72,77**). Such was their success, *More Bab ballads* appeared in 1873. Gilbert wrote several plays before *Thespis* launched his collaboration with Sullivan in 1871.

Gustave Doré, although a French artist, visited London every year to exhibit his paintings, and he illustrated a number of books in English. A self-taught infant prodigy, he supported himself by his periodical illustrations while still in his teens. His first humorous book illustrations for an edition of Rabelais in 1854 established his reputation, and he illustrated 119 books in all.

His friend Blanchard Jerrold wrote the text for their joint work *London; a pilgrimage* (1872), which covered every part of London and provided the best-known images of Victorian poverty (**76**). His output of drawings was prodigious and he was a great success in London society, yet he died bitterly disappointed by his failure to be recognised as a great painter in oils.

Kate Greenaway was the daughter of a draughtsman and engraver, John Greenaway. She was born in Hoxton, though family financial difficulties forced the family to move to Islington. She studied at the National Art Training School in the South Kensington Museum. Some of her drawings were displayed in the Dudley Gallery in the Egyptian Hall, Piccadilly, where they caught the eye of the Rev. W.J. Loftie, who bought them for the *People's Magazine* which he edited. Among her early freelance commissions were calendars and valentine cards for Marcus Ward & Co., the Belfast chromolithographers who also had a London office. The valentines were republished in a book, *The Quiver of love* in 1876, together with pictures by Walter Crane, though their work is difficult to tell apart at this early stage in their respective careers (**73**). Kate Greenaway's runaway success as a children's illustrator

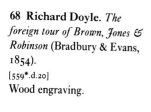

68 Richard Doyle. *The foreign tour of Brown, Jones & Robinson* (Bradbury & Evans, 1854).
[559*.d.20]
Wood engraving.

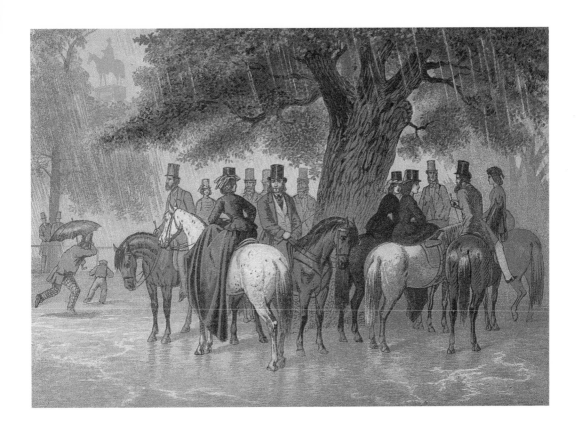

69 *The circling year* (Religious tract society, 1871).

[12330.k.10]

Unsigned illustration printed by Kronheim. 'A spring shower in the park.' Coloured wood-engraving.

came after Edmund Evans printed her *Under the window* in 1878.

Hugh Thomson, an Irishman, began his career with an apprenticeship to Marcus Ward & Co. in Belfast. In 1884 he moved to London to join *The English Illustrated Magazine* which was owned by Macmillan. Randolph Caldecott, the illustrator of children's books, was already on the staff, and Thomson was influenced by his style. Thomson illustrated a series on the character Sir Roger de Coverley and one on *Coaching days and ways*, both later published as books, and both giving an opportunity for the depiction of horses at which he excelled.

Macmillan had already published two volumes by Washington Irving in a small neat format, with gold-stamped green cloth covers and line drawings by Caldecott. They commissioned Thomson to illustrate another volume in the same style, *The vicar of Wakefield*, published in 1890. This was so successful that Thomson went on to illustrate *Cranford* in 1891 and *Our village* in 1893, all produced in the same format. Since Thomson was now working freelance, George Allen poached him to illustrate a fine edition of *Pride and prejudice*, with a splendid peacock design in gold on the green cloth cover. Macmillan retaliated by securing Thomson to illustrate the other five Austen novels in 1896 and 1897 (**75**).

Thomson's style of illustration became known as the 'Cranford' school after his success with Mrs Gaskell's novel of that name in 1891. C.E. Brock

Miss Crawley's affectionate relatives

70 W.M. Thackeray. *Vanity Fair* (Bradbury & Evans, 1849).

[i2654.d.9]

Illustration by the author: 'Miss Crawley's affectionate relations'. Wood engraving.

was one of its later exponents. It reflects a nostalgia for the 'good old days' before the industrialisation of the 1830s. The drawings have a gentle humour and great delicacy.

Thomson also used little drawings to decorate the contents pages. He extended his range to colour work after the turn of the century, when the fashion began for books with tipped-in colour plates produced by the half-tone process, but the increase in size and the colours which obscured his delicate lines detracted from the charm of his work.

71 Charles Bennett. *Poets' wit and humour*, selected by W.H. Wills, second edition (Ward Lock, [1882]). [11602.f.121] 'Spring.' Wood engraving.

72 W.S. Gilbert. *Bab ballads* (Routledge, 1851). [11660.b.11] Illustrations by the author. The ghost, the gallant, the gael and the goblin. Wood engraving.

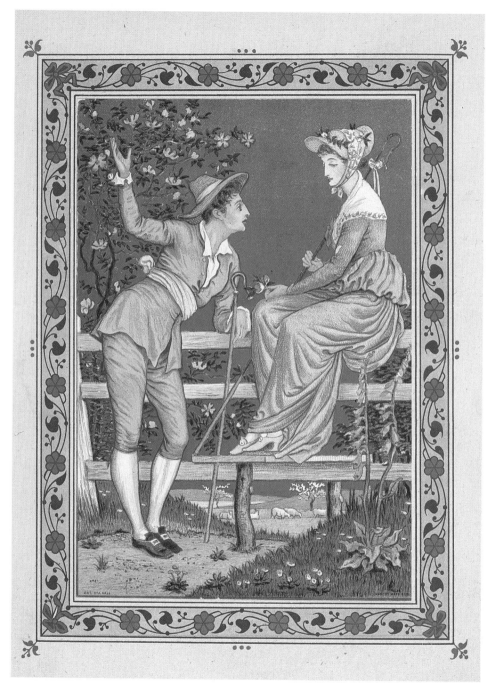

73 Kate Greenaway. *The quiver of love*, edited
by W.J. Loftie (Marcus Ward, 1876).
[11651.g.2]
A collection of valentines. Chromolithograph.

74 (*Opposite*): **P.H. Delamotte.** Matthew Digby
Wyatt, *The industrial arts of the nineteenth century
at the Great Exhibition, 1851* (Day & Son, 1851).
[Tab 1306.a]
Bedstead in zebra wood by Carl Leistler & Son of
Vienna. Chromolithograph.

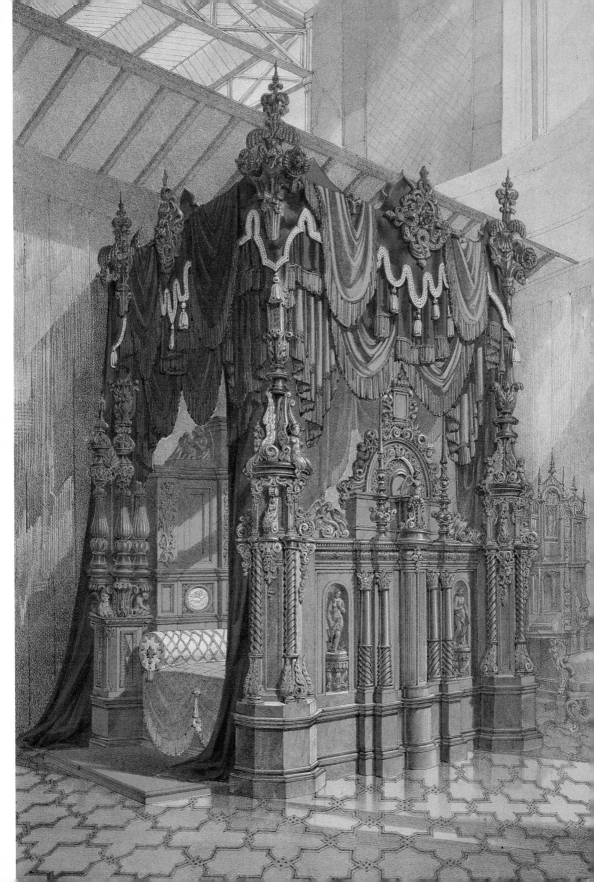

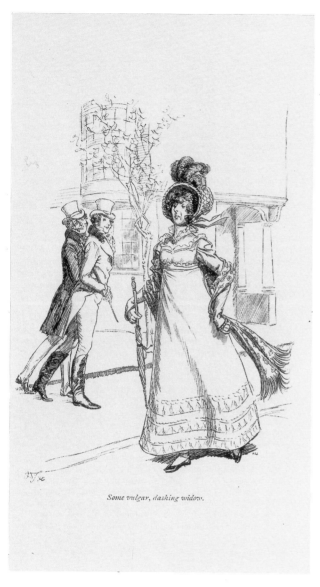

Some vulgar, dashing widow.

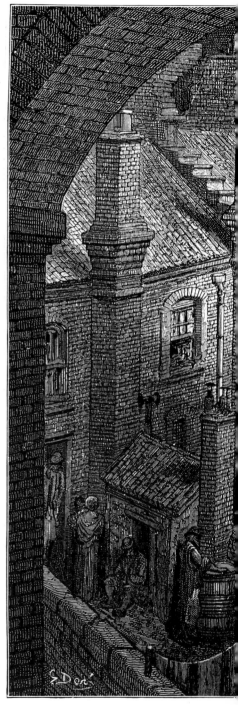

75 Hugh Thomson. Jane Austen, *Emma* (Macmillan, 1896).
[012621.h.27]
Line block.

76 (*Right*): **Gustave Doré.** Blanchard Jerrold, *London: a pilgrimage* (Grant, 1872).
[1788.b.20]
Wood engraving.

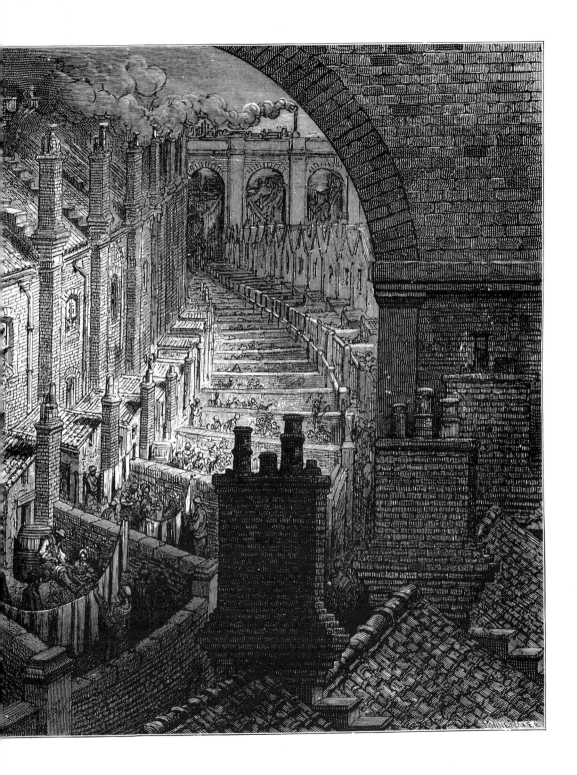

Suggestions for further reading

John Barr *Illustrated children's books* (The British Library, 1986).

David Bland *A history of book illustration* (Faber & Faber, 1969).

Robert M. Burch *Colour printing and colour printers*, new edition (Paul Harris, 1983).

John Harthan *The history of the illustrated book* (Thames and Hudson, 1981).

Simon Houfe. *The dictionary of British book illustrators and caricaturists 1800–1914* (Antique Collectors' Club, 1981).

Eric De Maré *The Victorian Woodblock illustrators* (Gordon Fraser, 1980).

Ruari McLean *Victorian book design and colour printing* (Faber & Faber, rev. ed. 1972).

Percy Muir *Victorian illustrated books* (Batsford, 1971).

Gordon N. Ray *The illustrator and the book in England from 1790 to 1914* (Pierpont Morgan Library, New York, 1976).

John Russell Taylor *The Art Nouveau book in Britain* (Paul Harris, Edinburgh, 1979).

77 W.S. Gilbert. *Bab ballads* (Routledge, 1851).
[11660.b.11]
Illustration from the poem 'John and Freddy'. Wood engraving.